Houston, Space City USA

Number Twenty

Sara and John Lindsey Series in the Arts and Humanities

Born on the bayou.
The City of Houston was established on the banks of Buffalo Bayou in 1836. From its headwaters on the prairie west of Houston, the bayou meanders around and through downtown Houston, eventually feeding into the Houston Ship Channel and south to Galveston Bay and the Gulf of Mexico.

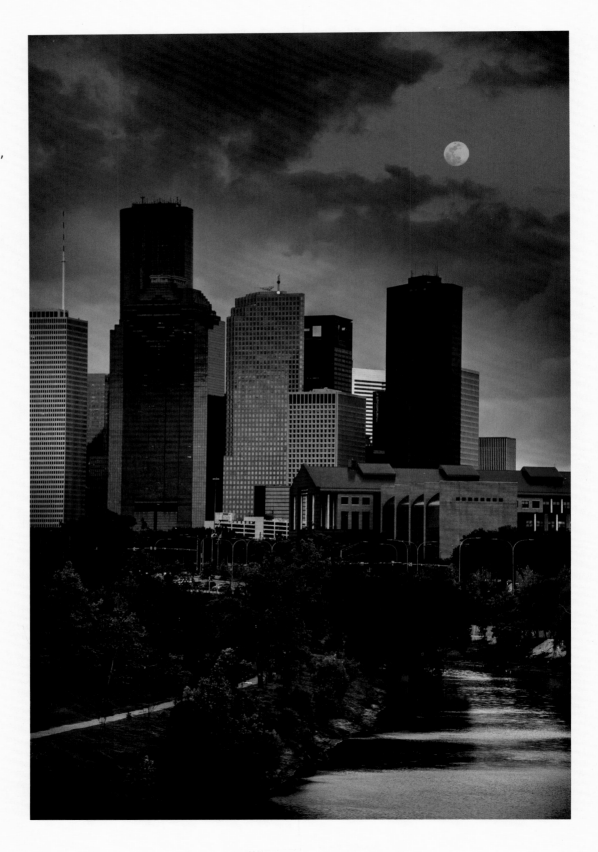

Houston, Space City USA

Ray Viator

TEXAS A&M UNIVERSITY PRESS
COLLEGE STATION

This paper meets the requirements of ANSI/NISO Z39.48–1992
(Permanence of Paper).
Binding materials have been chosen for durability.
Manufactured in China through FCI Print Group.

Library of Congress Cataloging-in-Publication Data

Names: Viator, Ray, author.
Title: Houston, Space City USA / Ray Viator.
Description: First edition. | College Station: Texas A&M University Press,
 [2019] | Series: Sara and John Lindsey series in the arts and humanities;
 number twenty | Includes bibliographical references and index. |
 Identifiers: LCCN 2018042650 (print) | LCCN 2018045510 (ebook) |
 ISBN 9781623497736 (ebook) | ISBN 9781623497729 | ISBN 9781623497729
 (cloth : alk. paper)
Subjects: LCSH: Texas—Houston—History—20th century. |
 Astronautics—Texas—Houston. | Manned space flight—History. |
 Lyndon B. Johnson Space Center—History.
Classification: LCC F394.H857 (ebook) | LCC F394.H857 V53 2019 (print) |
 DDC 976.4/1411—dc23
LC record available at https://lccn.loc.gov/2018042650

To Cynthia, the goddess of my moon and the center of my universe

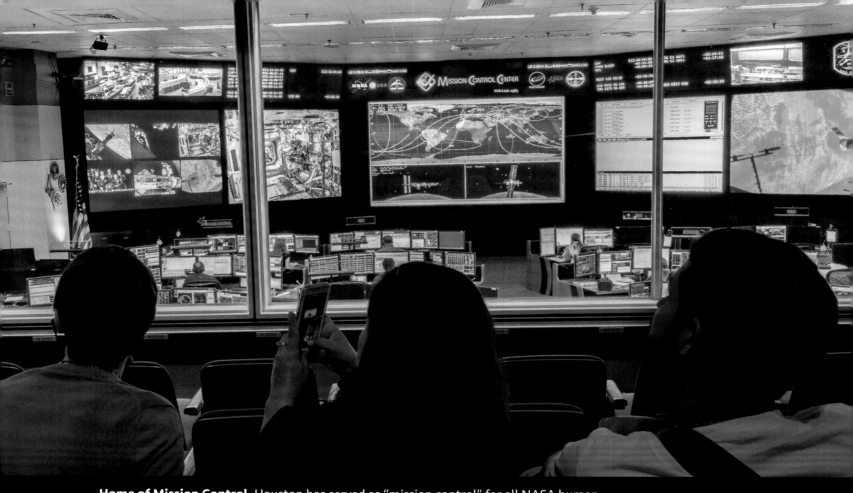

Home of Mission Control. Houston has served as "mission control" for all NASA human space flights since the launch of Gemini 4 in June 1965. Since then, mission control at Johnson Space Center has been responsible for all flight operations from the moment a US spacecraft cleared the launch tower at the Kennedy Space Center until it landed on Earth. Today, the JSC mission control center, also known as the flight control room, is staffed twenty-four hours a day and is responsible for managing all US International Space Station operations.

Contents

High-rise moonrise.
Dozens of high-rise
apartment buildings
and condos have
sprung up around
Houston, providing
a new vantage point
for residents to watch
sunsets as well as
moonrises.

Preface

"Houston. Tranquility Base here. The Eagle has landed."

—Neil Armstrong, from Apollo 11
July 20, 1969

This book is for everyone who grew up in the 1960s and can remember where they were when Alan Shepard became the first American in space, John Glenn became the first American to orbit the Earth, or Neil Armstrong became the first person to step on the moon and make that famous declaration to "Houston" . . . and the world. While the excitement of America's early space program may have dimmed over the years, many still feel an attachment to those heady space days of the '60s, especially if you lived in Houston at the time.

For everyone who has ever watched a space shuttle launch or spotted the International Space Station in the sky, this book is also for you. Likewise, it is for every young person who has ever thought they might be among those who take the next steps—perhaps to Mars or elsewhere in our amazing universe. And, for everyone who has ever thought about making a change and pursuing their dreams, this book is for you.

This book started as a dream to become a "serious" photographer more than twenty years ago. It began with a single photo that was shot as part of a personal challenge. My personal assignment? Take one photo illustrating the fact that Houston was the first word spoken from the moon. The photo in this book of the statue of Sam Houston pointing to the moon was one of my first attempts to capture and reflect that historical footnote. That photo from 1999 was the first of dozens of times over the years that I found myself orbiting the statue of Sam

Houston in Hermann Park trying to improve upon the image. My mission was finding the right combination of light, perspective, composition, angles, moon phases, and sky conditions to create new visual interpretations of "Houston: First Word from the Moon." In doing so I began to realize the difficulty and challenge of my personal photo assignment.

Photographing the full moon, even with today's sophisticated cameras, is neither easy nor simple. The challenge, however, was creatively stimulating, and I began to photograph the moon with other Houston landmarks. It also made me more curious about the moon, which spurred me to learn more about our world's closest heavenly body.

In the process, I also began doing more research about Houston's historical connections to the US space program. It's a fascinating story, and the more you become aware of the connections, the more connections you begin seeing all around Houston.

Some psychologists call this the "frequency illusion": the phenomenon in which something that has recently come to one's attention suddenly seems to appear with improbable frequency. My oldest daughter and I call this the "T-bird effect" because we started noticing more and more Thunderbirds after I bought a used blue T-bird as her first car.

Whatever the cause, and despite living and working in Houston for more than forty years, I started seeing connections between Houston and the space program all across the area. It inspired me to create this collection of photographs—along with a collection of both well-known facts and little-known anecdotes—to paint a picture of Houston's ties to the space program that many of us either simply overlook or take for granted.

As I started writing and selecting the photos for this book, my editor, Jay Dew of Texas A&M Press, gave me some great advice: "Think about explaining how this book is different from all the other books that have been written about the US space program and how it will be different from the dozens of books that will be written as we approach the fiftieth anniversary of the first time a human stepped on the moon."

For me, it's important to first say what this book is not. This is not a history book about the US space program. Many great books have already been written and published by historians and writers with far more insight and knowledge about the US space program. In the references, I have listed a few of those more authoritative books. They are great resources for anyone who wants to learn more about the important history of the US space program overall as well as Houston's pivotal role.

Instead of repeating just the well-known narrative of the space program, I've chosen to focus on some of the lesser-known aspects of NASA in Houston. Stories that are important, but often overlooked; anecdotes that are interesting and surprising and that might prompt the reader to say "I didn't know that."

At the same time, however, this isn't a book of space trivia, although some readers may see that. Instead, I like to think of this book as a series of conversation starters, something along

the lines of "did you know that. . . ." Anytime we can share new information or start a conversation with some fresh insight or context is a positive experience.

This also is not a science book, and it certainly isn't a scientific book or a book about physics, astrophysics, engineering, or math. But it is a book that appreciates and celebrates the science, physics, engineering, and math that govern all heavenly bodies and that thousands of men and women have mastered in order to better explore and explain the heavens.

This book also is not just a book of pretty pictures from space. Again, many great books have already been published with fantastic photos taken by astronauts aboard America's space vehicles. I have included a list of a few of my favorite space photobooks in the references, and I would challenge you to read them without being amazed at the beauty of this blue marble we call home.

So, what is my vision for this book? Quite simply, it is a visual celebration of Houston's many ties to the US space program and the role that our region has played in nurturing it, contributing to it, and benefitting from it for more than fifty years. With hundreds of astronauts trained in Houston over the years, their research and exploration missions have touched almost every segment of modern life, from the powerful computers and communications devices we hold in our hands to new materials and products that make our everyday life healthier and safer.

The book also celebrates the impact of the space program on our city and region. The space program raised Houston's visibility both nationally and around the world. It increased awareness of Houston on several levels, from personal experience like a group of Houston students touring Europe during the summer of 1969 and being cheered whenever local residents saw the word "Houston" on the side of their bus to being recognized as the first word spoken from the moon by Neil Armstrong.

Today, about 20 percent of the about one million annual visitors to Space Center Houston are from other countries. They travel to Houston in part to see, touch, and reflect upon one of the greatest scientific and engineering adventures of all time. They can't yet travel to the moon themselves, but Houston can get them close.

Houston has become a catch phrase for space in dozens of books and movies, including untold variations of "Houston, we've had a problem." Thanks to the space program, the city has been featured in films ranging from dramatic films like *Apollo 13* and *For All Mankind* to sci-fi films like *The Martian, Independence Day, Armageddon,* and *Space Cowboys.*

For Houstonians and visitors alike, this book is designed to help you discover and explore Houston's connections to the space program all around you. This book also is a challenge to each reader to take a fresh look at the moon and the heavens and rediscover the wonderment and natural curiosity that many of us first felt when we looked skyward and began to soak in the enormity of the universe.

This book is an homage to our ancestors who, without computers, Google, or even the foundations of math and scientific principles, were able to accurately determine and predict the movements and phases of the moon and sun. Even after much research and reading on the subject, I still can't fully grasp and understand—much less predict with any degree of accuracy—the basic movements of the moon without the help of a computer application like the Photographer's Ephemeris. (I admit that I didn't even know what an ephemeris was before I started this project.)

This book also is a reflection of the inspiration—personal, spiritual, and scientific—that the moon and the heavens have stirred in humanity throughout the ages. You see it reflected in our religions and societies, in literature, in music, and in all forms of art. Just as the moon's gravity invisibly pulls and tugs on our planet's oceans, causing tides and impacting everyday life, so too have the majesty of the moon, planets, and stars touched our human psyche.

This book is also a celebration of the whimsical and humorous, the fancy and the fantastical that surround us every day, if we just take the time to look.

Finally, this book is an ode to simpler times, when people would sit outside and look up at the sky in an unrushed appreciation of the wonders of nature all around us.

I hope that this book inspires other would-be photographers—as well as artists, engineers, students, teachers, explorers, rocket scientists, (non-rocket) scientists, mathematicians, computer programmers, and a host of others—to pursue their creative dreams and interests.

Acknowledgments

This book would not have been possible without the support and encouragement from many people, but five deserve special recognition.

Michael Kincaid from the Johnson Space Center was the first to encourage me to pursue the concept for the book and provided very thoughtful guidance when I needed it the most. He later passed the baton to Linda Matthews-Schmidt, who helped me navigate the myriad departments and directorates that make up the Johnson Space Center, and who helped arrange dozens of photo shoots on site over the past two years.

Kathy Adams Clark was the first to view my portfolio of moon photos and see the potential for a photo book. She remains a trusted mentor and coach for me and my photographic pursuits. She was also the one who introduced me to Texas A&M University Press.

Jay Dew, editor in chief at Texas A&M University Press, listened to my pitch about a photo book about the connections between Houston and the space program. To my great surprise, he approved my book proposal. Over the course of the past two years, he has provided steady and gentle guidance in shepherding the book from concept through several drafts and on to the finished book that you see here today.

Frank Michel and I have been friends and colleagues since we first met on the night copy desk of the *Houston Chronicle* almost forty years ago. When I finally completed the manuscript, I knew it needed a thorough and detailed editing before I submitted it to Texas A&M University Press. The one person with whom I had the most confidence in finding and fixing my grammar, correcting my syntax, punching up my headings and captions, and overall polishing up my manuscript was Frank. This book would not flow as smoothly and consistently without his many contributions.

At the risk of forgetting to recognize anyone who has provided encouragement, arranged a photo shoot, answered my many questions, suggested photo ideas, or critiqued my drafts, I want to express my profound appreciation to each of the following:

George Abbey, Joyce Abbey, David Alexander, B. J. Almond, Judy Alton, Ngo Anhtuan, Randy Baker, Karen Barbier, Lisa Barton, Alan Bean, Bill Begley, Alan Bernstein, Allison Bills, Deidre Black, Brian Blake, Marcia Blount, Jim Boles, Genie Bopp, Rodney Bowersox, Francesco (Frankie) Camera, Christian Castro, Victoria Castro, Betty Chapman, Brenden Chenoweith, Myritha Cleveland, William Close, Deborah Acosta Conder, Terri Cook, Barrett Counts, Chris Culbert, Anne Culver, Cissy Segal Davis, Brandi Dean, Joel Draut, Mickey Driver, Jeanette Epps, Jeff Falk, Dan Feldstein, Rick Ferguson, Antonio Flores, Paul Freund, Susan Ganz, Randy Gordon, Alessandro Grattoni, Fred Griffin, Gwen Griffin, Oscar Gutierrez, Liz Guyer, Bob Harvey, Judith Hayes, Monica Hernandez, Denny Holt, Roger Hord, Brock Howe, Alex Ignatiev, John E. James, Patrick Jankowski, Jeannette Jimenez, Elmer (Bubba) Johnson, Jim Johnson, Lucian Junkin, Joy H. Kelly, Melissa Kean, Beth Kobermann, Ryan Kobermann, Lucas Kobermann, Addison Kobermann, Kurt Koopman, Gene Kranz, Ulrich Lotzmann, Arturo Machuca, Lynnette Madison, Rebecca Marianno, Greg Marshall, Joe Massucci, Jerry Matthew, Emily McGowan, Lauren Meyers, Brad Miller, Melinda Mintz, Bob Mitchell, Marc Morrison, Andrea Mosie, John Murphy, Judy Murphy, Loral O'Hara, Jim Olive, Mark Ott, Kim Parker, David Parks, Sarah Peterson, Jose Arnaldo Pinero, Laurence Pinsky, Dena Propis, Chuck Pool, Pat Reiff, Raul Reyes, Isidro Reyna, Kevin Rigsby, Timothy Ronk, Jennifer Ross-Nazaal, Chuck Russell, Dan Seal, Christine Shupla, Angela Smith, Koree Smith, Prudence Smith, Xavier Smith, Gale Smith, Mark Sowa, Paul Spana, Helen Stanley, Blythe Starkey, Megan Sumner, Carolyn Sumners, Jeffrey Sutton, Scott Timms, Jim Townsend, Keith Tran, Sylvester Turner, Lee Vela, Cynthia Viator, Melodie Wade, Shannon Walker, Mike Williams, Marcus Wilkins, Paul Williamson, Andrea Wilson, Henry Wilson, Eric Winslette, Melissa Wren, Donald Zacek, and Gloria Zacek.

Houston, Space City USA

**From Bayou City to
Space City.** Once called
"Bayou City" because
of its many bayous,
Houston became known
as "Space City USA" in
the 1960s after NASA
selected the city to
be the home of the
Manned Spacecraft
Center, now known as
Johnson Space Center.

Chapter 1

Moon Shot

Making Houston the Home
of Human Space Flight

I believe that this nation should commit itself to achieving the goal, before this decade is out, of landing a man on the moon and returning him safely to the Earth.

—President John F. Kennedy
May 25, 1961, speech to a Joint Session of Congress

With his historic words, President John F. Kennedy formally set in motion ambitious efforts to ensure the country's leadership in space. He also touched off a different kind of space race as cities across the nation vied to host a $200 million federal research laboratory—one of the largest economic development opportunities of its era—that would become the future home of the Manned Spacecraft Center. It was a competition Houston and its civic, business, and political leaders were determined to win for the honor and prestige as well as the high-tech jobs such a prize would bring to the city.

Houston's historic role as home of US human spaceflight is due to many benefactors, but four individuals stand out for their roles at the birth of the program: Kennedy, Lyndon B. Johnson, Albert Thomas, and George R. Brown.

Kennedy provided the nation and Houston with a vision, a goal, and a rallying cry for a country eager to assert its place at the forefront of the emerging space race. Johnson, first as a US senator from Texas and then as US vice president, was a determined political leader with a strong allegiance to his home state. As Senate majority leader and chair of the Senate's Special Committee on Space and Astronautics, Johnson helped write and enact the legislation in 1958 that led to the creation of NASA. In 1973, President Richard Nixon signed a proclamation renaming the Manned Spacecraft Center the Johnson Space Center in his honor.

Two individuals with deep ties to their adopted home town of Houston—US Representative Thomas and Rice University board chairman and business leader Brown—brought a powerful mix of business, political, and academic connections and resources that were critical in the decision to locate NASA's Manned Spacecraft Center in Houston. Without the special contributions of Thomas and Brown, it is unlikely that Houston ever would have landed the prized center and thus would never have played such a pivotal role in America's space program over the past fifty-plus years.

Representative Albert Thomas

Like any successful politician, Thomas cared deeply for his district and worked to secure projects and funding important to the Houston area. There were practical programs like funding for roads, bridges, flood control, and the Port of Houston. Additionally, Thomas had set a

personal goal for his adopted city: to secure a national laboratory that would boost Houston's economy and raise its national and global profile.

During the 1950s, Thomas had kept a watchful eye out for big national research projects. His first target was to try to land a new national laboratory for the Atomic Energy Commission. That effort failed when the agency decided instead to build what is now the Fermi National Accelerator Laboratory outside Chicago, Illinois. While not successful, Thomas learned much about the process and continued to explore other opportunities. As early as 1958, he had urged the administrator of the new National Aeronautics and Space Administration (NASA) to consider Houston as a possible site for a NASA "laboratory." He tried to secure what eventually became the Goddard Space Flight Center, which instead was located in Maryland, just outside Washington, DC.

As chair of the House Appropriations Subcommittee for NASA appropriations, however, Thomas made sure that NASA's leadership understood his commitment that Houston should not be passed up again. Thomas reportedly spared no effort to lobby, cajole, and trade favors throughout the government to ensure favorable consideration of Houston's eventual bid. During the process, he was said to have pointed out to NASA leadership that "the road to the moon is through Houston." He also rallied Houston business leaders behind his efforts, with help from his former Rice University classmate and now influential business leader and Rice Board Chair George R. Brown.

When the decision was made at last to locate the Manned Spacecraft Center in Houston, it was no coincidence that Thomas was the first to announce it during a phone call to the Houston Chamber of Commerce. In fact, he made the call from the office of Vice President Johnson.

Although Thomas often downplayed his role—saying at one point that he "was only the water boy"—he could not escape the recognition by others involved in the successful effort. During a speech in Houston on November 21, 1963, the night before his assassination, President Kennedy led a tribute to Thomas at the former Houston Coliseum in downtown Houston. Kennedy said, "I don't know anyone who has been a greater help in trying to get the job done, not just for Houston and not just for Texas, but for the entire United States, than Albert Thomas."

Kennedy also noted that Thomas "has helped steer this country to its present eminence in space next month when the United States of America fires the largest booster [rocket] in the history of the world into space for the first time . . . the United States next month will have a leadership in space which it wouldn't have without Albert Thomas."

George R. Brown

Brown, like his college roommate and friend Albert Thomas, was from a small Texas town and only moved to the "big city" of Houston to attend Rice University. Although he did not graduate from Rice, the university had a big impact on Brown. Throughout his career, he

ceaselessly worked to promote and advance Rice. Brown joined Rice's board of trustees in 1943 and served as chair from 1950 to 1967.

With his older brother, Herman, Brown made his fortune transforming their small road paving company, Brown & Root, Inc., into one the largest construction companies in the world. Along the way, he continued to forge deep personal and political ties to Thomas and Johnson. In 1961, then-Vice President Johnson named Brown to the National Space Council that Johnson chaired. The appointment positioned Brown—and thus Houston—with greater insight into the country's space program, including the site selection for future research facilities.

When Thomas later told Brown and others that Houston's chances of securing the facility could be bolstered if the city would donate one thousand acres of land, Brown knew just where to look for such a large tract. Earlier, Brown had attempted to buy land southeast of Houston near Clear Lake from Humble Oil & Refining. Humble also had a record of donating land, having given the federal government acreage for expansion of Ellington Field during World War II. As chair of the Rice board, Brown negotiated with Humble to donate the land to the university, which in turn offered it to NASA as part of Houston's successful bid.

Brown also led Rice University's efforts to address one of NASA's other major criteria for the new space research laboratory: "access to academic research and scientific programs to support the agency's missions and goals."

Other contributors

Many others had meaningful roles in the genesis of what is today NASA's Lyndon B. Johnson Space Center. Houston's case was bolstered, for example, by three other Texans in Congress at the time, US Speaker of the House Sam Rayburn, US Representative Olin Teague, chair of the Manned Space Flight Subcommittee of the House Committee on Science and Astronautics, and US Representative Bob Casey, member of the House Committee on Science and Astronautics. Others within the Houston business community helped welcome and support NASA's move to Houston, including Morgan Davis (president of Humble Oil & Refining), Rice University President Kenneth Pitzer, leaders from the then-Houston Chamber of Commerce, and many others.

Houston's success and its unique position in the US space program also is the due to the work and dedication of thousands: astronauts and engineers, center directors and scientists, researchers and lab assistants, artists and craftspeople, dreamers and explorers. Each year NASA honors dozens of individuals at each of its centers for their contributions to the US space program.

"In a very real sense, it will not be one man going to the moon it will be an entire nation. For all of us must work to put him there," said President Kennedy.

The Case for Houston

The site selection process for the $200 million "manned spaceflight laboratory" was hotly contested across the country, with intense lobbying from several states and regions, including President Kennedy's home state of Massachusetts. At the same time, Houston's interests were well represented in Washington by Vice President Johnson, Representative Thomas, and other members of the Texas delegation. While other cities and regions could arguably claim that Houston had an unfair advantage in terms of political influence, they were hard pressed to argue that the Houston area wasn't well qualified.

NASA administrator James E. Webb's site selection team had identified eight essential criteria that it used in evaluating almost two dozen cities and locations across the country during the late summer of 1961. Based on data from the 1961 edition of the then-Houston Chamber of Commerce's Houston Facts economic and demographic publication, the facts successfully address and support the essential criteria used by NASA's site selection team. Below are the reasons outlined in the site selection procedure sent to President Kennedy on September 14, 1961.

1. Transportation

> "*Capability to transport by barge large, cumbersome space vehicles (thirty to forty feet in diameter) to and from water shipping. Preferably the site should have its own or have access to suitable docking facilities. Time required in transport will be considered. Availability of a first-class all-weather commercial jet service airport and a Department of Defense air base installation in the general area capable of handling high-performance military aircraft.*"

By 1961, Houston was the second largest US seaport in total tonnage, moving an estimated 58 million tons of cargo annually. Located on the Houston Ship Channel, the Port of Houston connected the city to the world through a fifty-mile, three hundred-foot wide and thirty-six-foot deep channel. The port at the time featured twenty-five public docks, sixty-five private docks and forty-seven terminal docks for barges. The port was served by ten common barge carriers and twenty specialized barge lines. Additionally, Houston had water access to the entire Gulf Coast through the nearby Intracoastal Canal and was served by six major railroad systems.

In terms of air service, the then-Houston International Airport (Hobby Airport) was a gateway to Latin America and Europe. Ten airlines provided passenger and air cargo service for more than 1.4 million passengers annually. The Houston Airport System today handles more than fifty-five million passengers, including more than ten million international passengers. In addition, Houston was the home to Ellington Air Force Base, with three runways on 2,362 acres, located fifteen nautical miles from downtown Houston.

Mind the gap. The space shuttle *Independence* was moved through Galveston Bay and then under the Kemah Bridge on its way to its new permanent home at Space Center Houston. Formerly known as *Explorer*, the model is a full-scale, high-fidelity replica of the space shuttle. Photo courtesy of NASA

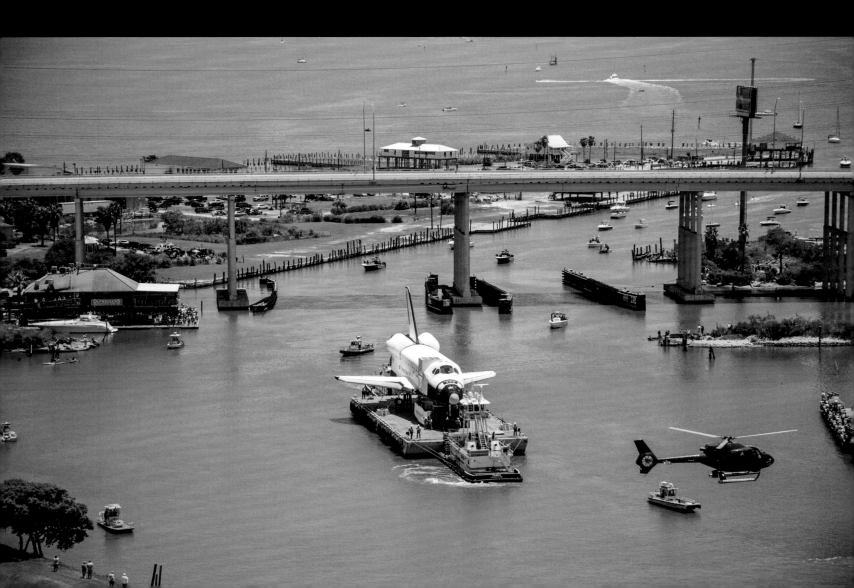

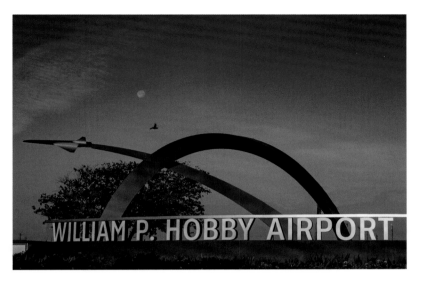

Ready for take-off from day one. Located within a few miles of Johnson Space Center, both Ellington Airport and Hobby Airport have supported NASA's many flying needs, including commercial and general aviation.

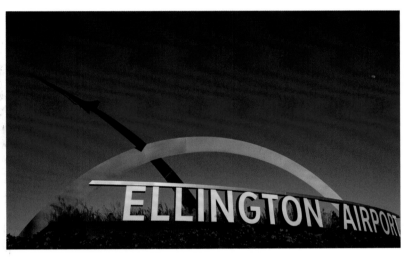

From airbase to airport to spaceport. Ellington Airport began operations more than a century ago as an airbase during World War I. Since the 1960s it has been used as the home base for JSC's aircraft flight operations as well as flight training for NASA's astronaut corps. The city of Houston purchased Ellington in 1984 and operates it today as a third civil airport.

Seafaring to spacefaring. The Houston Ship Channel ensures deep-water access from the Port of Houston to Galveston Bay and the Gulf of Mexico.

2. Communications

"Reasonable proximity to main routes of the long-line telephone system."

The Chamber of Commerce's records at the time noted that more than 500,000 telephone lines were installed in Houston.

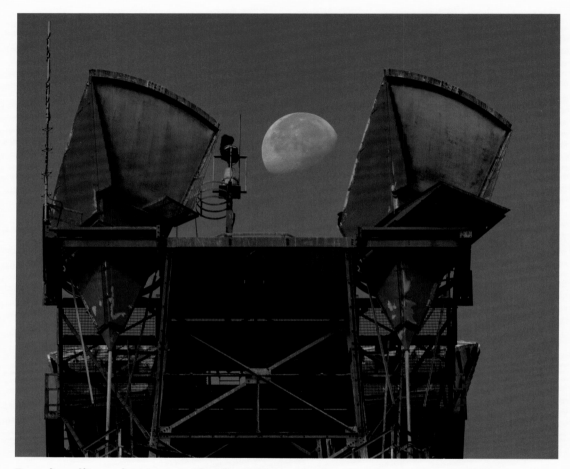

From long lines microwave to the Big Bang. Horn-reflector antennae were developed at Bell Labs in 1961 and then widely used for microwave relay links in the AT&T Long Lines microwave network. Native Houstonian and Rice University graduate Robert Wilson was part of the Bell Labs team that used a horn reflector antenna to discover cosmic microwave background radiation. The research earned the 1978 Nobel Prize in Physics and helped solidify the Big Bang theory in science.

3. Local Industrial Support and Labor Supply

"An existing well-established industrial complex including machine and fabri-cation shops, to support a research and development activity of high scientific and technical content, and capable of fabricating pilot models of large space-craft. A well-established supply of construction contractors and building trades and craftsmen to permit rapid construction of facilities without premium labor costs. Local industrial support and labor supply."

Houston was one of the largest manufacturing centers in the Southwest in the early 1960s as a result of the concentration of energy companies in the region. The area's metals industry manufactured a variety of products. The city ranked above all other Southwestern cities in three key measures: value added by manufacture, manufacturing payroll, and capital investment in new manufacturing. At the time, Harris County was the home to more than 1,600 manufacturing companies with more than 93,000 workers and an annual payroll of more than $150 million.

Tiny measures to vast universe. Atec Manufacturing has been working for Johnson Space Center since the 1960s. In 2016, the family-owned firm was named Small Business Contractor of the Year by NASA. The company's work includes manufacturing and certifying jet engine parts to within one-millionth of an inch, thinner than a human hair.

4. Community Facilities

"Close proximity to a culturally attractive community to permit the recruitment and retention of a staff with a high percentage of professional scientific personnel. Close proximity to a well-established institution of higher education with emphasis on an institution specializing in the basic sciences and in space related graduate and postgraduate education and research."

Best seats in the universe. The Burke Baker Planetarium at the Houston Museum of Natural Science has presented astronomical programs to millions of visitors since it opened in 1964.

First in space science. Rice University established the country's first space science department in 1963 and opened its Space Science and Technology building in 1966. Many NASA scientists and engineers at Johnson Space Center have studied at Rice.

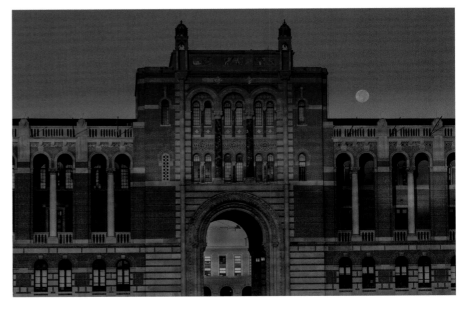

Houston was home to a number of cultural amenities at the time, including the Houston Symphony, Houston Grand Opera, Alley Theatre, Museum of Fine Arts, Houston, Contemporary Arts Museum, and the Houston Museum of Natural Science.

More than 20,000 students were enrolled in ten area universities and colleges, including the University of Houston, Rice University, Texas Southern University, and the University of St. Thomas. In addition, the Texas Medical Center included Baylor College of Medicine, the University of Texas MD Anderson Cancer Center, and more than a dozen other medical institutions.

5. Electric Power

"Strong local utility system capable of developing up to 80,000 KVA of reliable power."

Chamber records at the time noted that non-residential electric consumption totaled 5.5 million KWH. Today, Houston's electric utility providers deliver more than 82 million megawatt hours of electricity to 2,010,036 residential, 280,327 commercial, 767 municipal, and 2,035 industrial customers in its 5,000 square mile regional service area.

Powering the space race and more. Houston's strong and reliable supplies of electricity have enabled the region to meet NASA's power needs and have also fueled tremendous growth and economic expansion throughout the region.

6. Water

"Readily available good-quality water capable of supplying 300,000 gallons per day potable and 300,000 gallons per day industrial."

Houston leaders had been addressing the city's long-term water needs for many years, and by 1961 Lake Houston was already providing 150 million gallons a day. Two new projects were also underway at the time and were scheduled to provide another 1.2 billion gallons a day when completed.

Water to meet growing needs. The Clear Lake City Water Authority was created in 1963 to serve the rapidly growing area around Johnson Space Center. It now provides more than twenty million gallons of water per day.

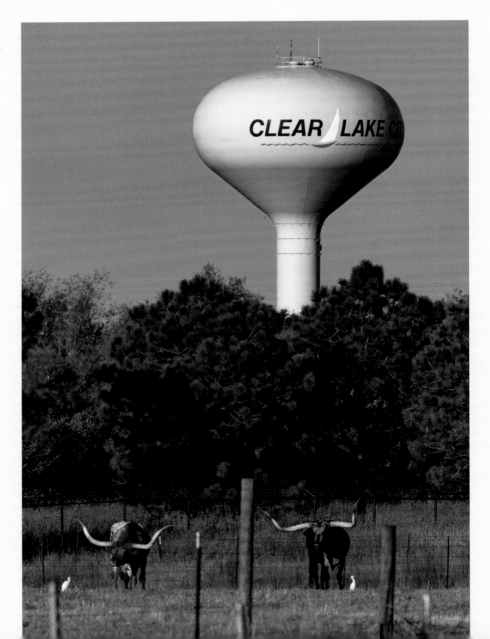

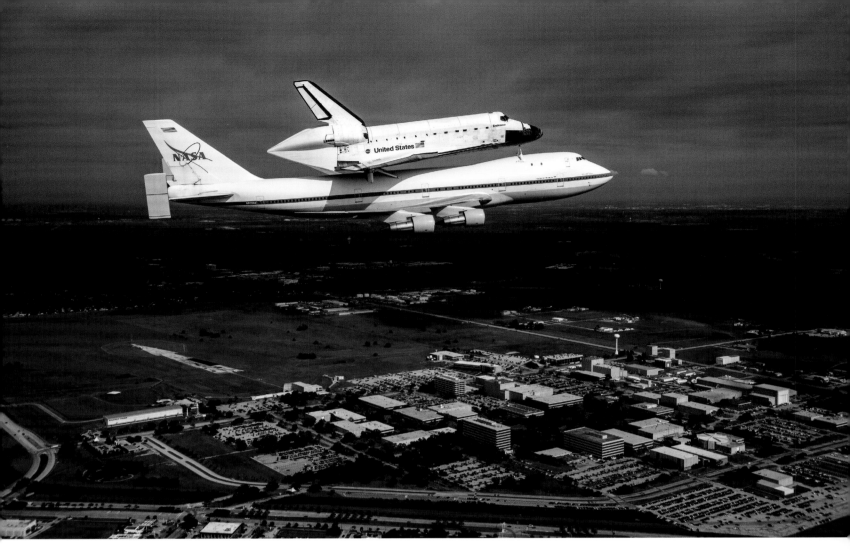

Homecoming flight. The space shuttle *Endeavour* made its final pass over Johnson Space Center on September 20, 2012, as part of the final ferry flight scheduled in the space shuttle program era. Houston's offer of one thousand acres near Clear Lake played a significant role in securing the Manned Spacecraft Center for Houston. Photo courtesy of NASA

7. Area

"One thousand usable acres with a suitable adjacent area for further development. Suitable area in the general location for low hazard and nuisance subsidiary installations requiring some isolation."

In Houston's formal proposal to NASA, Rice University agreed to donate one thousand acres of land in the Clear Lake area, about twenty-five miles south of downtown Houston. Another 620 acres were made available for purchase.

8. Climate

"A mild climate permitting year-round, ice-free, water transportation; and permitting out-of-door work for most of the year to facilitate operations, reduce facility costs, and speed construction."

The average daily maximum temperature in Houston in winter is 64 degrees; in summer, 91 degrees; in spring and fall, 80 degrees. The average daily minimum temperature in winter is 46 degrees; in summer 75 degrees; in spring and fall, 60 degrees.

Year-round outdoor activities. While a mild climate was an important part of NASA's site selection criteria from a construction and operations perspective, Houston's weather has the added benefit of providing NASA's workforce with plenty of outdoor activities throughout the year.

Tampa, Tranquility Base here . . . ?

Although it is hard to imagine today, Houston was not NASA's first choice for the Manned Spacecraft Center. In the fall of 1961, as NASA's site selection team reviewed potential locations, the area around MacDill Air Force Base in Tampa, Florida, emerged as the preferred location. This was in part because of plans to close Strategic Air Command operations at the base, freeing up the space for NASA. Houston's proposal, including the donation of land by Rice University, ranked second. Before a decision could be made, however, the Air Force decided not to close MacDill, effectively ending Tampa's opportunity to become the first word spoken from the moon.

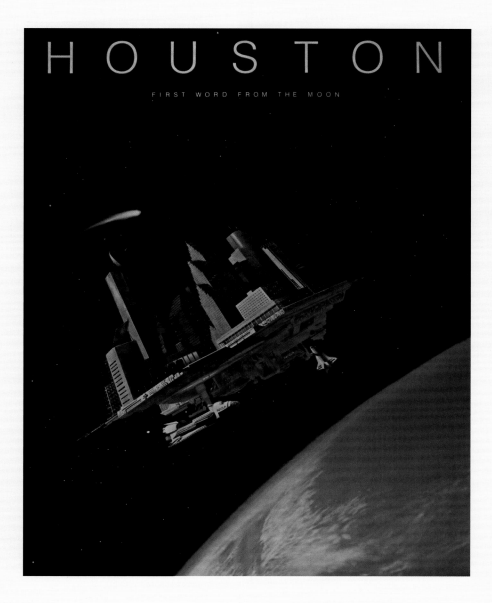

First word from the moon. As part of efforts to pull Houston out of a recession in the 1980s, city leaders and the business community mounted a national marketing campaign that sought to demonstrate the diversity of the area's economy. A key component of the campaign included a stylized version of Houston's skyline riding atop a shuttle-supported space station and titled "Houston: First Word from the Moon." Photo courtesy of Greater Houston Partnership, Pat Rawlings

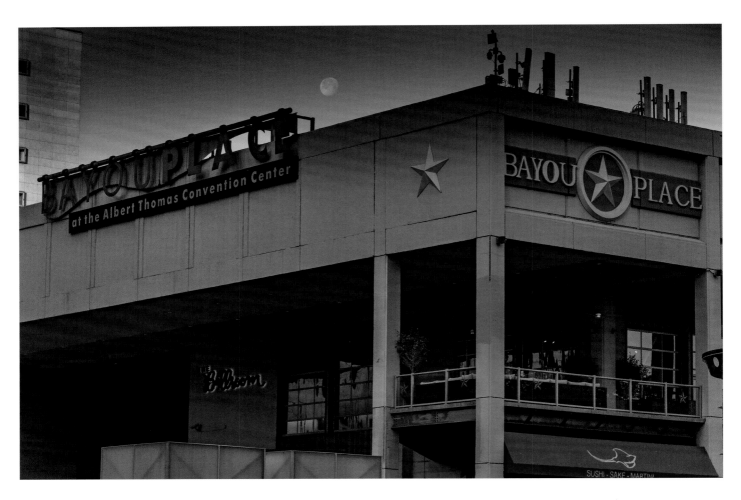

Honoring the "water boy" who helped land NASA in Houston. Recognizing his many contributions to the Houston area, including helping to secure NASA's Manned Spacecraft Center, a new downtown convention center was named for US Representative Albert Thomas in 1967. Many items from his Washington, DC, office were later put on public display in what is now known as Bayou Place at the Albert Thomas Convention Center.

Homing in on space business. Houston has taken giant leaps to promote space business opportunities by creating and hosting SpaceCom, the Space Commerce Conference and Exposition. The annual event focuses on opportunities in the aerospace and space industries as well as the application of space technologies to other industries.

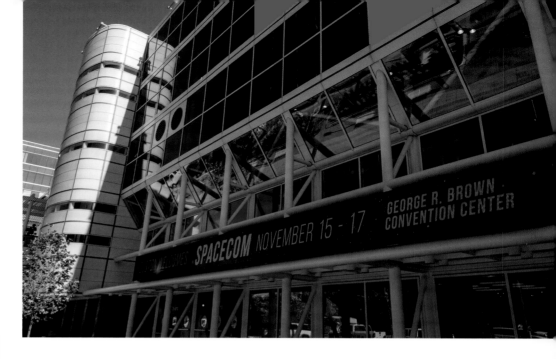

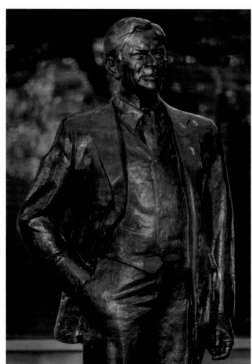

Houston builder George R. Brown. George R. Brown played a critical role in helping Houston become the home of NASA's Manned Spacecraft Center. His construction firm, Brown & Root, built much of Johnson Space Center as well as large portions of the Gulf Freeway. His statue is located in Discovery Green adjacent to the George R. Brown Convention Center, on land that one of his companies once owned.

Space walk. Whether it's serendipity or part of a grand artistic design, the carpet of Houston's George R. Brown Convention Center suggests images of planets. With more than 1.9 million square feet of floor space, that's a universe of subliminal messaging.

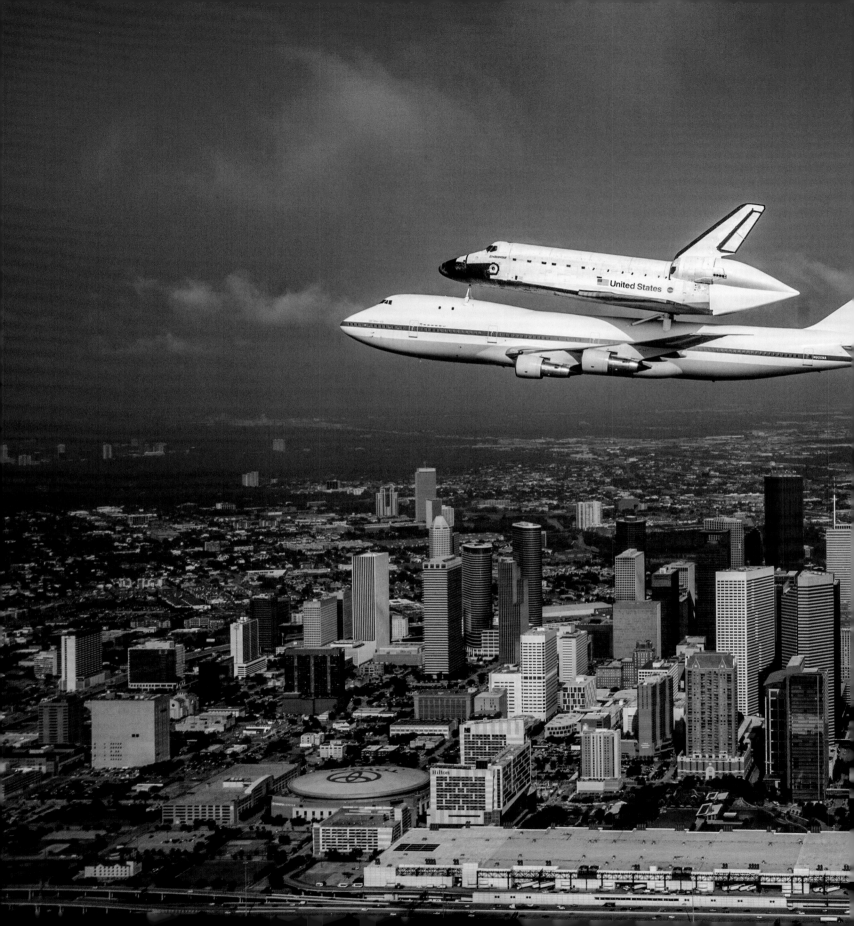

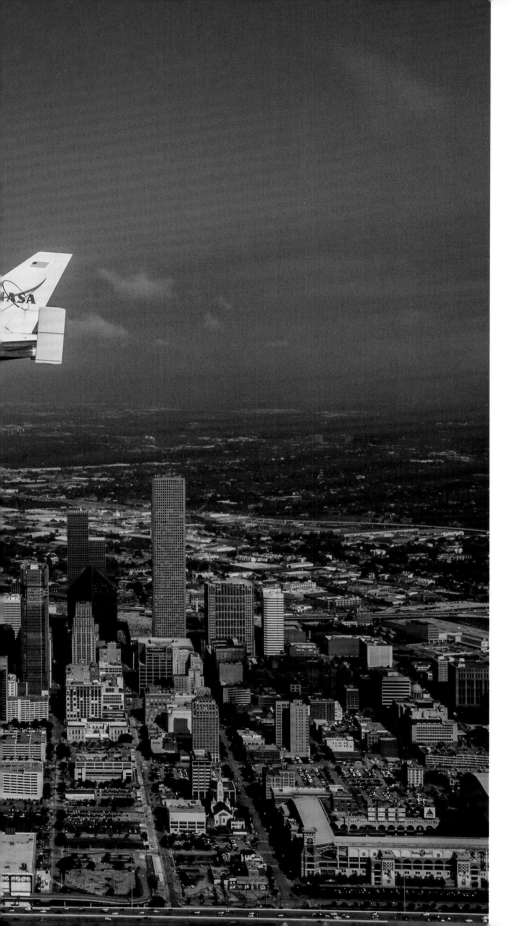

Houston-style commuting. From the first orbital test flight of the Space Transportation System shuttles in 1981 through the final flight of the shuttle *Atlantis* in 2011, five space shuttles flew a total of 135 missions. In 2012, the space shuttle *Endeavour* was ferried by NASA's Shuttle Carrier Aircraft over Houston en route to a stopover at Ellington Airport. Photo courtesy of NASA.

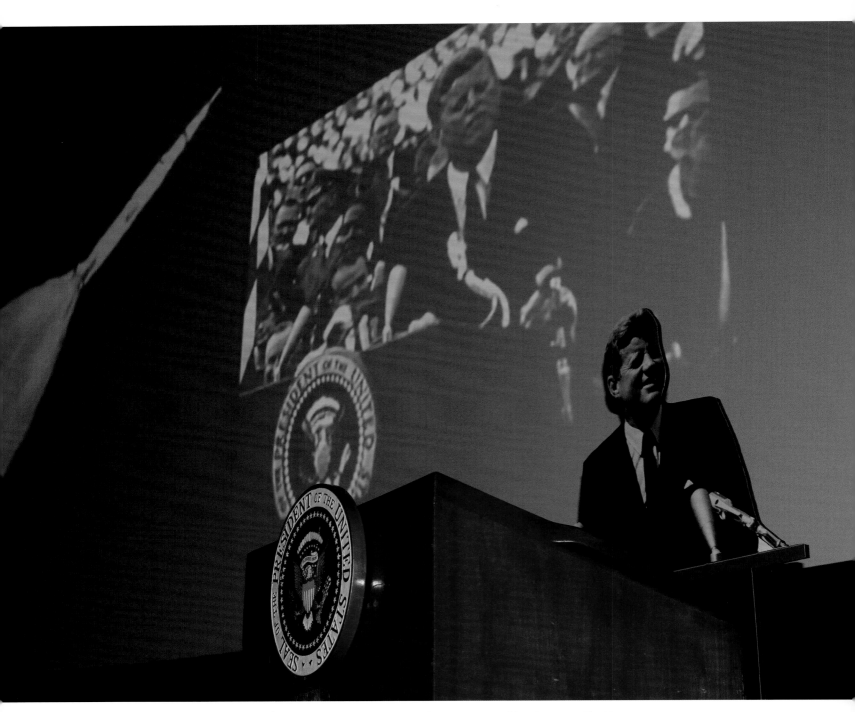

To the moon and back. A US flag carried to the surface of the moon and back on Apollo 11 was presented to Johnson Space Center Director Robert Gilruth in 1969 by members of the crew. The flag hangs on the campus of Johnson Space Center below a photograph of President Kennedy during his famous space speech at Rice University.

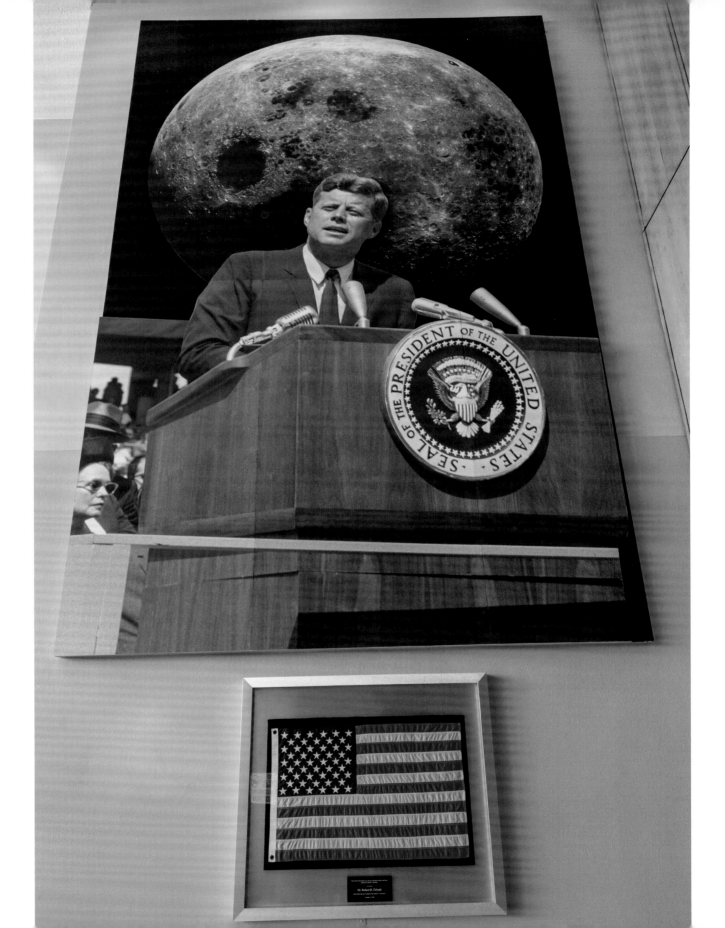

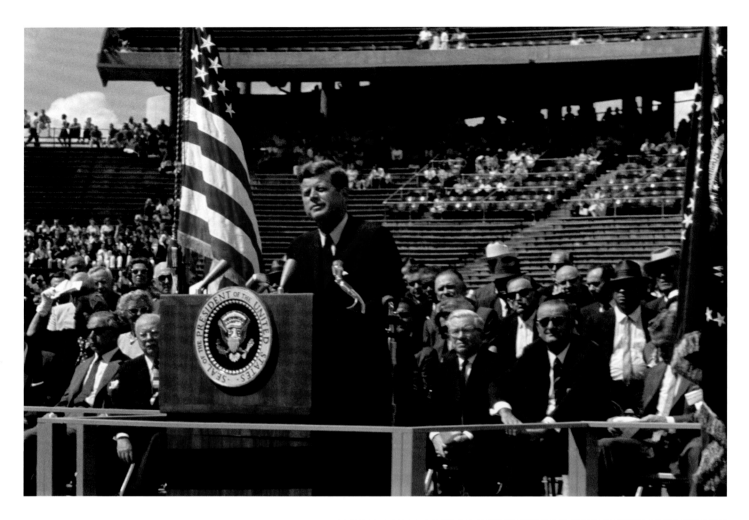

Soaring words and vision. President Kennedy delivered his historic speech at Rice University on September 12, 1962. "We choose to go to the moon in this decade and do the other things, not because they are easy, but because they are hard."

But why, some say, the moon? Why choose this as our goal? And they may as well ask: why climb the highest mountain? Why 35 years ago *Why does Rice play Texas* fly the Atlantic? We choose to go to the moon in this decade, not because that will be easy, but because it will be hard -- because that goal will serve to organize and measure the best of our energies and skills -- because that challenge is one we are willing to accept, one we are unwilling to postpone, and one we intend to win.

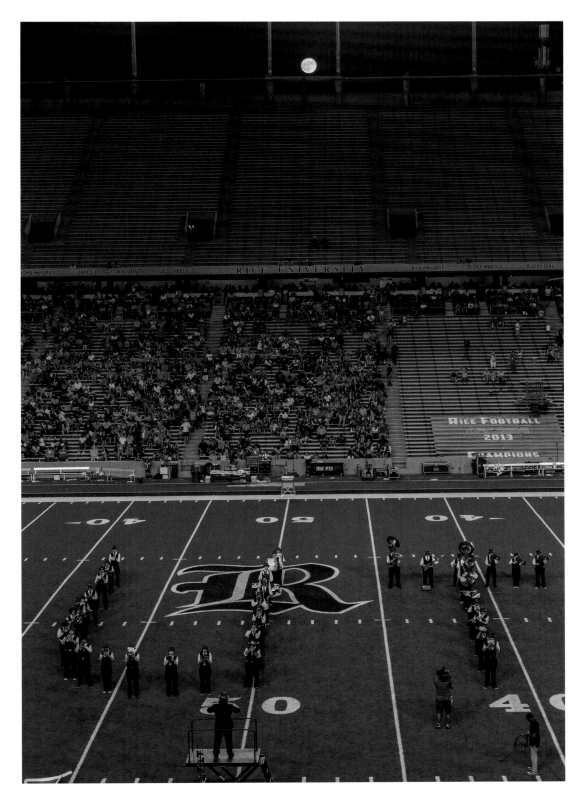

Why does Rice play Texas? President Kennedy's handwritten notes on the draft of his speech at Rice University's football stadium show that he added the rhetorical comment "why does Rice play Texas" just before arguing that "we choose to go to the moon . . . not because they are easy, but because they are hard." With two thousand students in 1962, Rice faced stiff competition on the gridiron against the University of Texas with its twenty-five thousand students.

*But this city of Houston, this State of Texas, this country of the United States
was not built by those who waited and rested and wished to look behind them.
This country was conquered by those who moved forward—and so will space.*

—President John F. Kennedy, Rice University, September 12, 1962

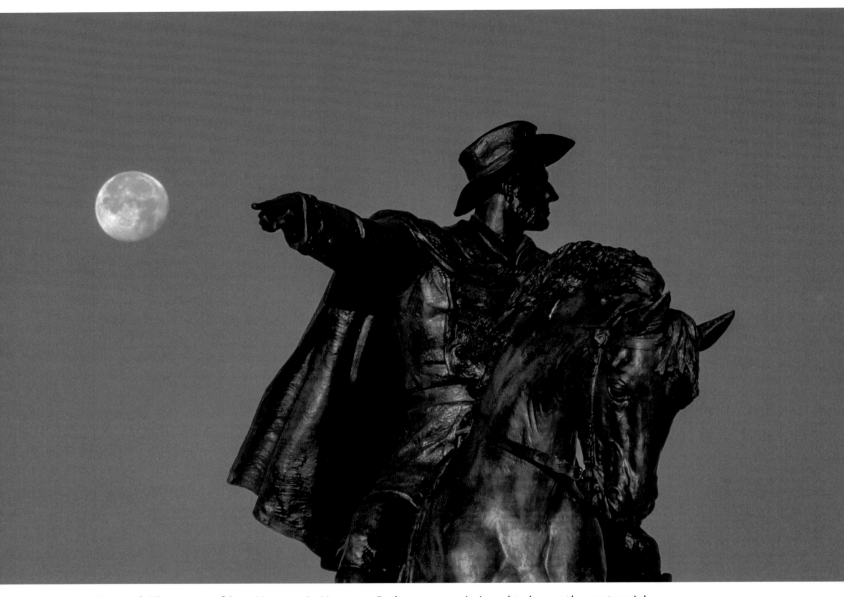

Onward. The statue of Sam Houston in Hermann Park was commissioned to honor the centennial of Houston's victory over the Mexican army at the battle of San Jacinto in 1836. The statue has Houston pointing eastward to the fields of San Jacinto—and to the rising moon.

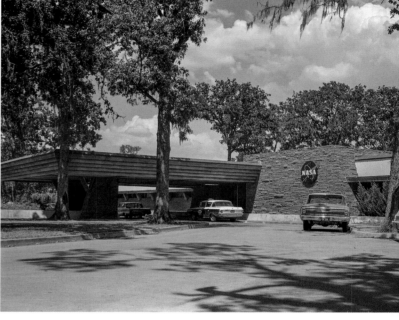

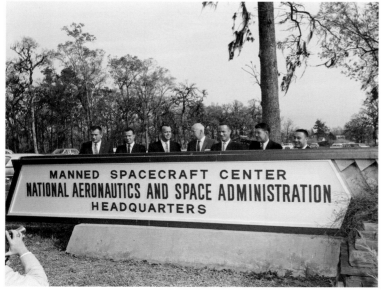

Early NASA headquarters. The former Farnsworth & Chambers Co. building at 2999 South Wayside served as temporary offices for the Manned Spacecraft Center's early management team from 1962–64. The building is a protected City of Houston landmark, a recorded Texas historic landmark, and is listed in the national register of historic places. It now houses the headquarters for the Houston Parks and Recreation Department.

No place but Texas. Before it became the home of Johnson Space Center, the area was a working ranch and home to dozens of cattle. Texas longhorns now graze on JSC property as part of the longhorn project, a joint effort among Johnson Space Center, the Clear Creek Independent School District, the Houston Livestock Show and Rodeo Association, and the Texas Longhorn Breeders Association of America.

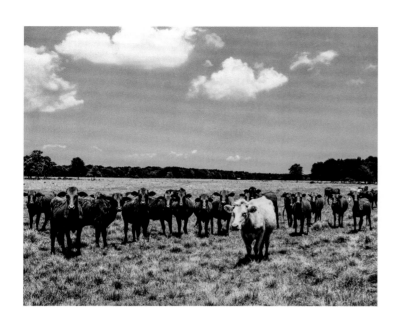

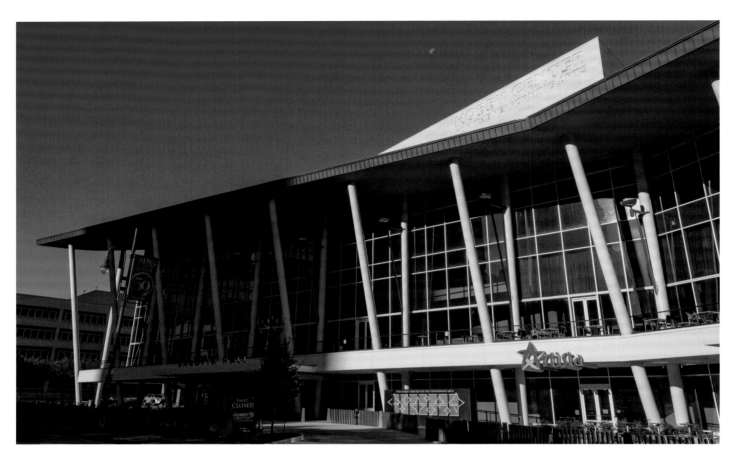

Historic site for NASA, JFK, and Albert Thomas.
NASA hosted the Project Mercury Summary
Conference at the Sam Houston Coliseum in 1963
to update the Houston community about its
plans. President Kennedy gave his last speech on
November 21, 1963, the night before he died, during
a dinner at the Coliseum to honor Representative
Albert Thomas and his pivotal role in bringing
NASA's Manned Spacecraft Center to Houston. The
site is now the home of the Hobby Center for the
Performing Arts.

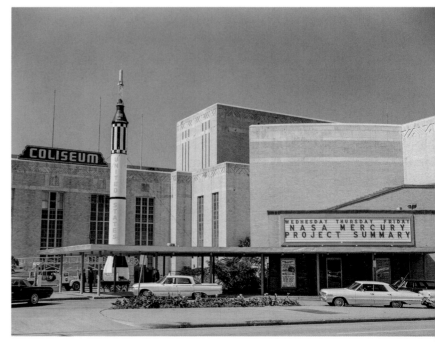

Texas-sized welcome. The Mercury 7 astronauts—Scott Carpenter, Gordon Cooper, John Glenn, Virgil "Gus" Grissom, Wally Schirra, Alan Shepard, and Deke Slayton—were welcomed to Houston in 1962 at the Sam Houston Coliseum along with a Fourth of July celebration that included cowboy hats and a downtown parade in their honor. Seven years later, thousands of Houstonians flocked to downtown Houston for a parade honoring the crew of Apollo 11: Neil Armstrong, Michael Collins, and Buzz Aldrin. Following the Houston event, the astronauts went on a forty-five-day "Giant Leap" tour across the United States and to twenty-five countries. Photo courtesy of the Houston Public Library

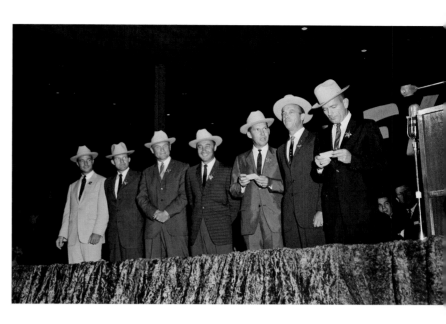

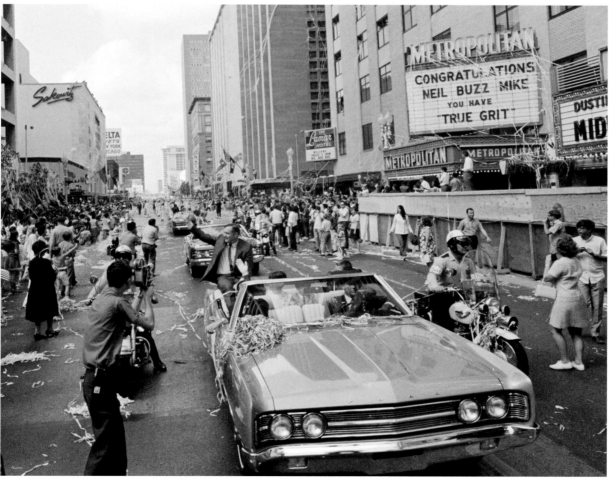

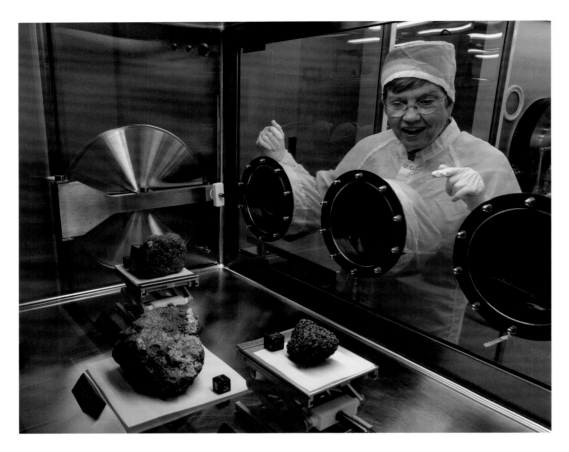

Rocking our world. Even after more than fifty years of examination and research, lunar samples continue to excite NASA scientists and researchers from around the world. The six Apollo moon landings returned 2,200 separate samples weighing 842 pounds from six different exploration sites on the lunar surface. About 75 percent of the lunar materials are permanently housed at the Lunar Sample Laboratory Facility, which formally opened on July 20, 1979, the tenth anniversary of the Apollo 11 lunar landing.

O, swear not by the moon, th' inconstant moon,
That monthly changes in her circle orb,
Lest that thy love prove likewise variable.

—William Shakespeare, Romeo and Juliet

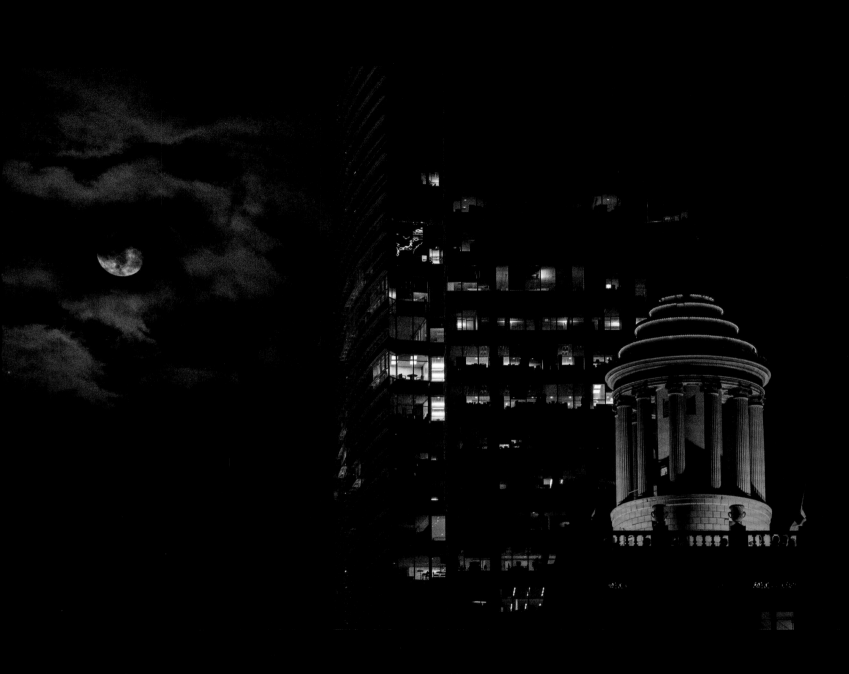

Cat's eye moon over downtown Houston. A cloud-shrouded full moon seems to cast a spell over downtown Houston and reinforces the urban myth that the iconic Neils Esperson building is haunted. The building was built in 1927 and is the only complete example of Italian Renaissance architecture in downtown Houston.

Space City USA

Continuing to Celebrate Space
Program Connection

Houston, Tranquility Base here. The Eagle has landed.—Neil Armstrong

Perhaps it was destiny that "Houston" was the first word spoken from the surface of the moon by Apollo 11 commander Neil Armstrong on July 20, 1969. Almost eight years earlier, Houston had been selected as the home of the new Manned Spacecraft Center. In 1961, President John F. Kennedy rallied the nation during a speech to more than twenty-five thousand at Rice University. Describing the rationale behind one of the most ambitious scientific and technical goals of the twentieth century, Kennedy proclaimed "we choose to go to the moon and do the other things, not because they are easy but because they are hard."

The daring and ambitious goal of putting a man on the moon captured the nation's imagination. Nowhere was that more evident than in Houston as the city welcomed astronauts, engineers, and rocket scientists with open arms. In the summer of 1962, Houston threw one of the city's largest celebrations at the time. The downtown Fourth of July parade, honoring the Mercury 7 astronauts, was followed by a festive barbecue and appreciation ceremony in the Sam Houston Coliseum. This was just one example of the euphoria that swept Houston after its selection for the new Manned Spacecraft Center. It seemed as if the whole city had contracted space fever.

People from all walks of life—business leaders, politicians, university presidents, teachers, students—were looking for creative and imaginative ways to celebrate and show their support for the astronauts and make the space program part of their lives. Many of those early displays of affection remain visible throughout Houston today. Some connections are obvious, like the naming of the Houston Astros and the Houston Astrodome or the city's first major amusement park, AstroWorld. And, when the NBA Rockets moved from San Diego to Houston in 1971, the name was a perfect fit. Over the years, Houston named other professional sports franchises with space or aerospace themes, including the WNBA Houston Comets and two hockey teams, the WHA Houston Aeros (1972–78) and the AHL/IHL Houston Aeros (1994–2013).

Other connections between the space program and Houston are hidden in plain sight, like the patches on every Houston police officer's uniform that have proudly proclaimed "Space City U.S.A." since the mid-1960s.

Connections can also be found in the multi-faceted tributes to the first lunar landing that are located in Tranquillity Park in downtown Houston. A few miles south of downtown, Hermann Park visitors can learn about space at the Houston Museum of Natural Science's Burke Baker Planetarium or take a quiet break on a granite "Moonscape" bench overlooking McGovern Lake. Other connections are tucked away in quiet places like the public artwork honoring John Glenn, the first American to orbit Earth, and Soviet cosmonaut Yuri Gagarin, the first human in space. Tributes to both men are located side-by-side in Gragg Park, the home of the first temporary offices for the Manned Spacecraft Center in Houston.

Still other connections reflect the interest of companies and organizations that have sought to be associated with the space program. Dozens of area firms, for example, have "Space City," "Space Center," "Rocket," or similar space themes in their names. Even area nonprofit organizations have incorporated a space moniker either into their names or into their programs. The Space Center Rotary Club of Houston, for example, has presented the National Space Trophy each year since 1987 to honor those who have contributed to the US space program. Likewise, in the 1980s, Houston's business community incorporated "Houston: First Word from the Moon" into its marketing and economic development campaign. And when Super Bowl LI was held in Houston in 2017, NASA and the US space program were featured prominently throughout the NFL Fan Zone, including mock-ups of the Orion capsule and Mars rover.

Houstonians also have adopted and incorporated space-related themes and images into both public art installations and private artwork. Images of the moon, rockets, and shuttles can be found around Houston on murals, traffic control boxes, and park benches, as well as inside the elevators of the Marriott Marquis in downtown Houston.

More than just a marketing ploy, however, Houston has been the physical home for the human space program. Each American astronaut who has ever flown aboard a US spacecraft since 1965 has lived in Houston as he or she trained and prepared for missions. Houston also has been the temporary home of many foreign astronauts who have flown aboard the Space Shuttle and International Space Station. From the original seven Mercury astronauts to the most recent astronaut class, more than four hundred astronauts have called Houston home before their journey into space. The list includes:

> Alan B. Shepard, the first American in space
> John Glenn, the first American to orbit Earth
> Neil Armstrong, the first person to walk on the moon
> Sally Ride, the first American woman in space
> Gene Cernan, the last person to walk on the moon
> Guy Bluford, the first African-American in space
> Franklin Chang Dìaz, the first Hispanic-American in space
> Ellison Shoji Onizuka, the first Asian-American in space
> Christa McAuliffe and Barbara Morgan, the first teachers in space
> Shannon Walker, the first native Houstonian to fly in space

Some lived in Houston only while preparing for their missions and then moved to other parts of the country after finishing their careers with NASA. Many, however, made Houston their permanent home. Shepard, for example, later became a successful businessperson in Houston and served as a commissioner on the Port of Houston Authority.

Today, Houston continues to be the home of astronauts preparing for missions on the International Space Station and other future destinations.

Space City USA. Houston enthusiastically embraced the US space program with the opening of NASA's Manned Spacecraft Center in the early 1960s. Even today, the uniforms of Houston police officers proudly proclaim Houston as "Space City U.S.A."

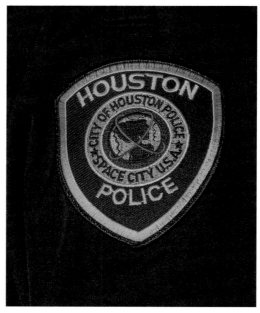

Native Houstonian. Of the almost 550 men and women who have flown in space since the early 1960s, only one astronaut has been a native Houstonian: Shannon Walker. Walker grew up in southwest Houston, attended Westbury High School, and holds three degrees from Rice University: a bachelor of arts in physics and both a master of science and a doctorate in space physics. Six years after being selected as part of the nineteenth class of astronauts, she became the first native Houstonian to fly in space as flight engineer for Expedition 24/25, a 163-day mission aboard the International Space Station.

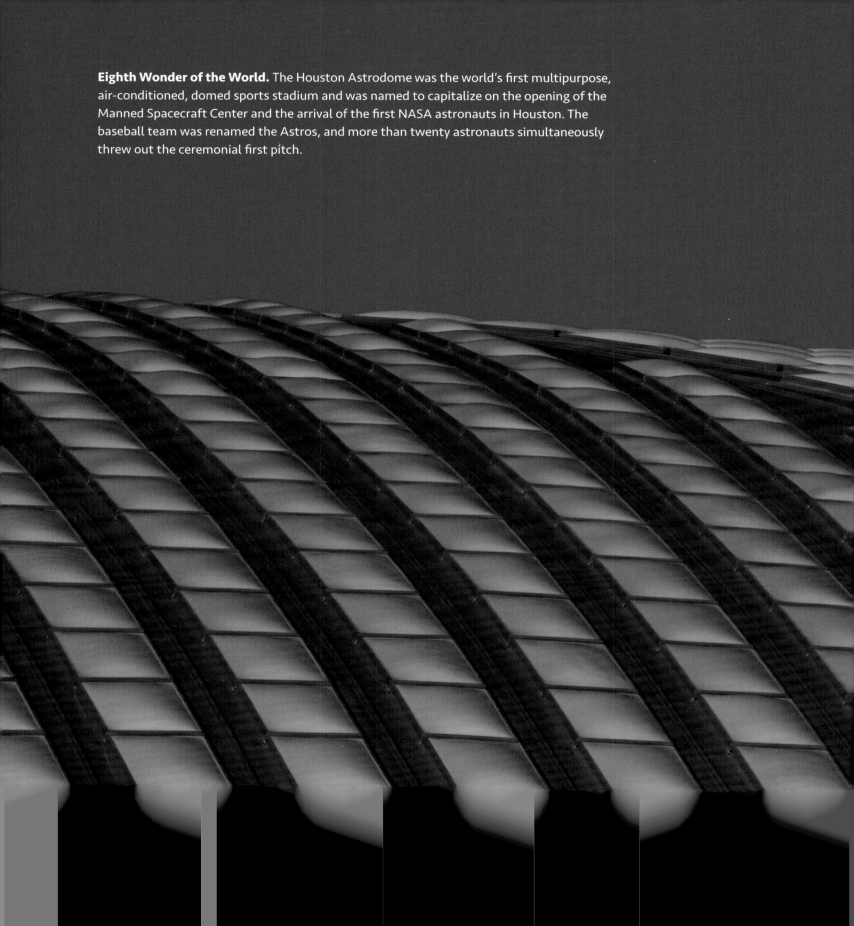

Eighth Wonder of the World. The Houston Astrodome was the world's first multipurpose, air-conditioned, domed sports stadium and was named to capitalize on the opening of the Manned Spacecraft Center and the arrival of the first NASA astronauts in Houston. The baseball team was renamed the Astros, and more than twenty astronauts simultaneously threw out the ceremonial first pitch.

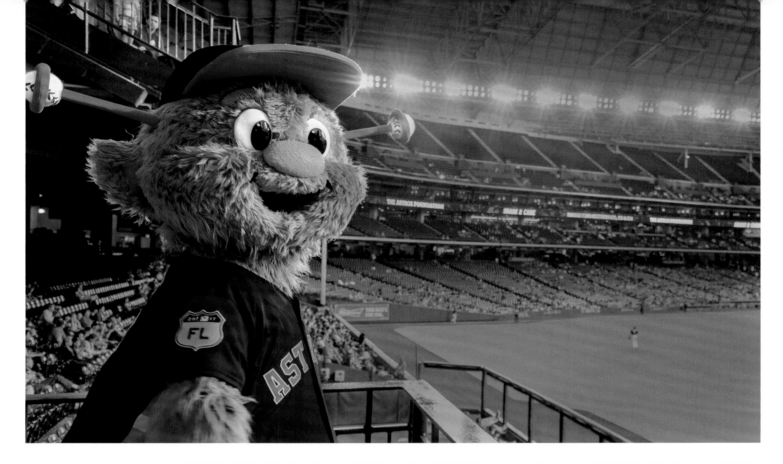

Making the rounds.
Orbit, the team mascot for the Houston Astros, can be found roaming the stands of Minute Maid Park during each Astros home game.

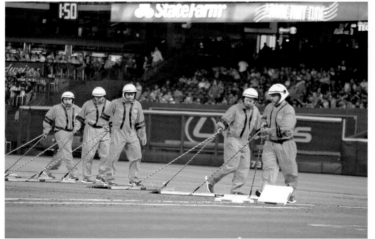

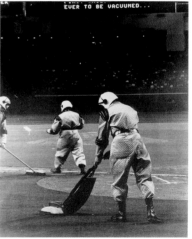

Not moondust. Between innings during Astros games in the Astrodome in the 1960s, grounds crewmembers wore spacesuits and helmets and cleaned the baseball diamond with vacuums. More recent grounds crewmembers wore updated spacesuits and helmets during special promotions in 2015 at the current home of the Astros, Minute Maid Park. Photos courtesy of the Houston Astros

Play ball! Home to MLB's Houston Astros, Minute Maid Park was completed in 2000 to replace the Astros' former home, the Houston Astrodome.

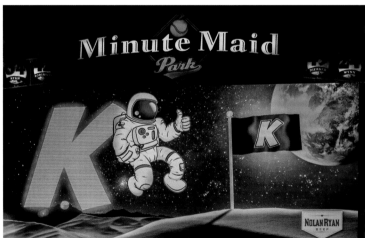

Astros fever sweeps Houston. While it took less than a decade for NASA to land a human on the moon, the Astros needed more than five decades to reach the pinnacle of baseball and win the World Series for their hometown. In the process, space themes popped up everywhere, from the Minute Maid scoreboard to celebratory shirts and street signs.

Shooting for the stars. Although they didn't start in Houston, the Rockets had the perfect team name when the franchise moved to Houston in 1971. The Rockets won back-to-back NBA championships in 1994 and 1995, and over the years the team's roster has featured some of the top players in the history of the NBA.

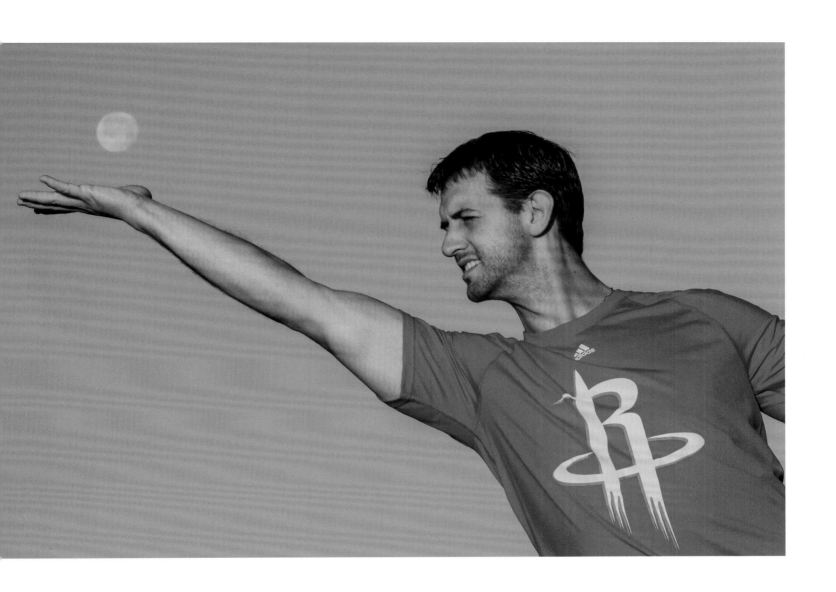

"We came in peace for all mankind." A wall on the south side of Tranquillity Park includes the historic words from the commemorative plaques located on the ladders of each of the Apollo lunar modules.

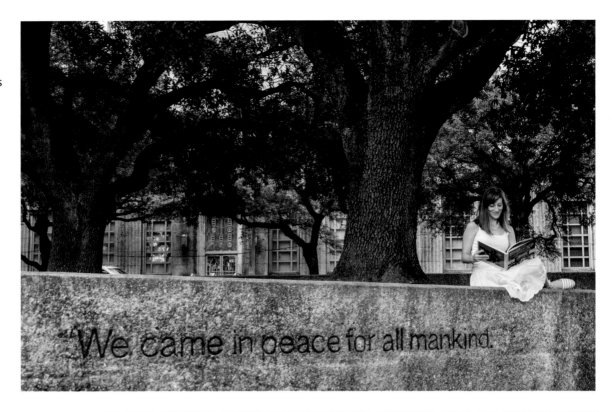

A tranquil setting. Located next to City Hall (background), Tranquillity Park provides a quiet oasis for downtown workers, including Mayor Sylvester Turner. The layout of the park was designed to represent the lunar surface, while the park's towering cylinders were inspired by the Apollo 11 rocket boosters.

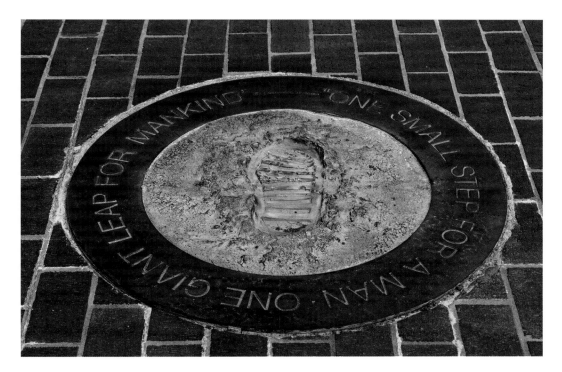

From Tranquility Base to Tranquillity Park. Located in downtown Houston, Tranquillity Park was officially dedicated in 1979 on the tenth anniversary of the historic lunar landing. It is named after the Sea of Tranquility, where man first landed on the moon during the Apollo 11 mission on July 20, 1969. Bronze plaques in several languages are located along the main entrances of Tranquillity Park and feature the first words transmitted by Neil Armstrong from the moon. A replica of one of the footprints left on the moon by Neil Armstrong is also located in the park.

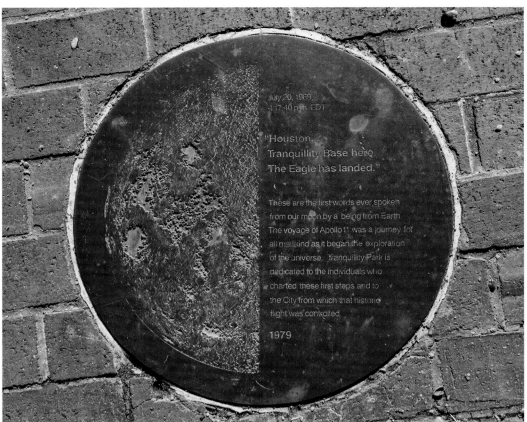

Transportation history.
Artwork created by 150 children born in 1986 is featured on seven seventy-foot pillars titled "Seven Wonders" along Buffalo Bayou. The pillars were built to commemorate Houston's and Texas' 150th birthday in 1986. The transportation pillar includes many space-related themes etched in stainless steel plate.

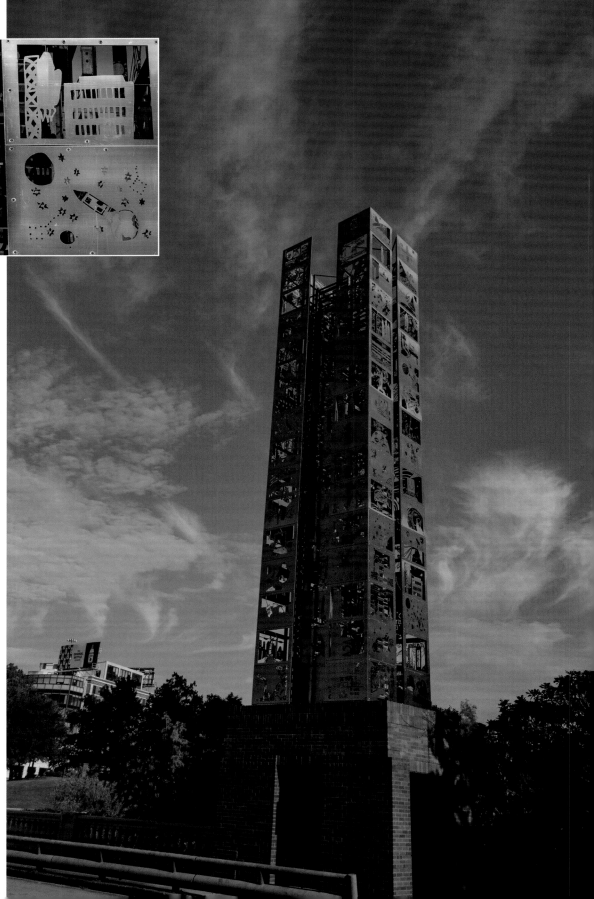

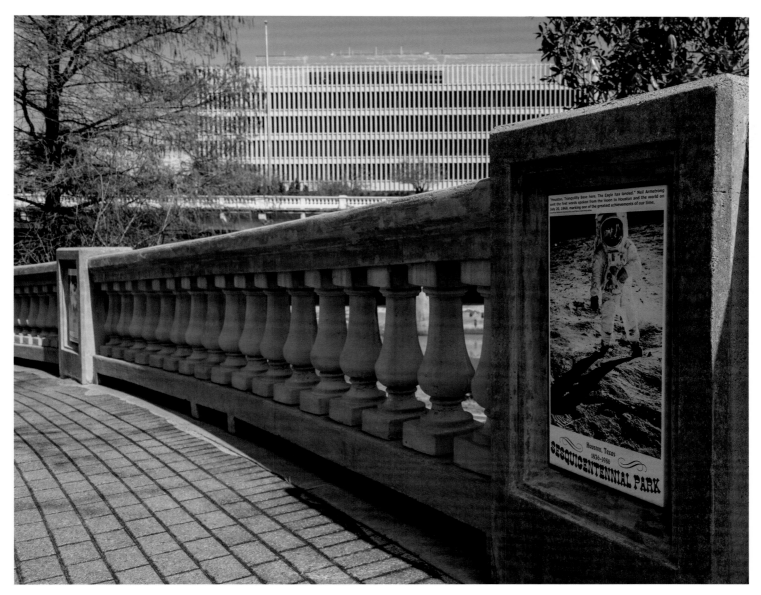

Houston milestone. Houston's Sesquicentennial Park features tributes to milestones in the city's history, including the 1969 Apollo 11 lunar landing.

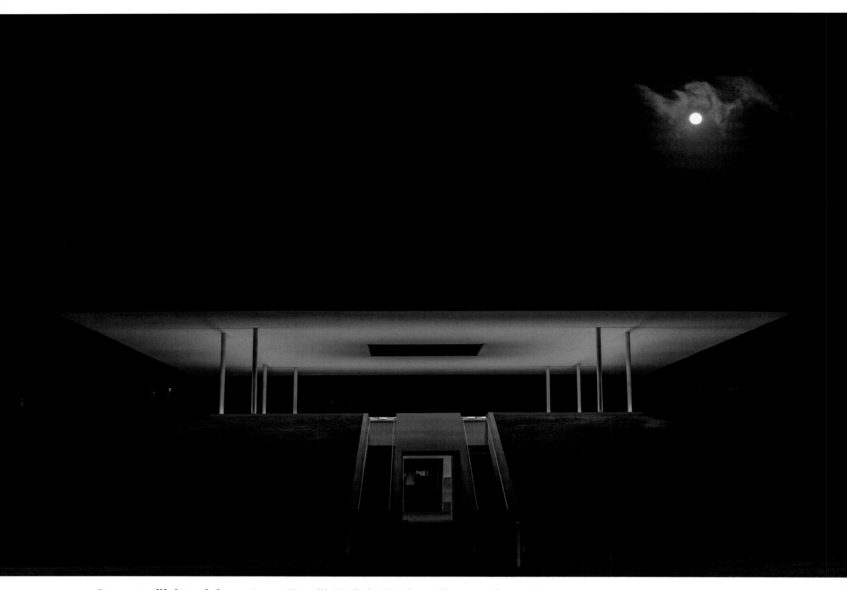

Serene twilight epiphany. James Turrell's Twilight Epiphany Skyspace, located next to the Shepherd School of Music on the Rice University campus, is acoustically engineered to host musical performances and to act as a laboratory for music school students. Turrell's composition of light compliments the natural light present at twilight and makes the Skyspace into a serene venue for reflection.

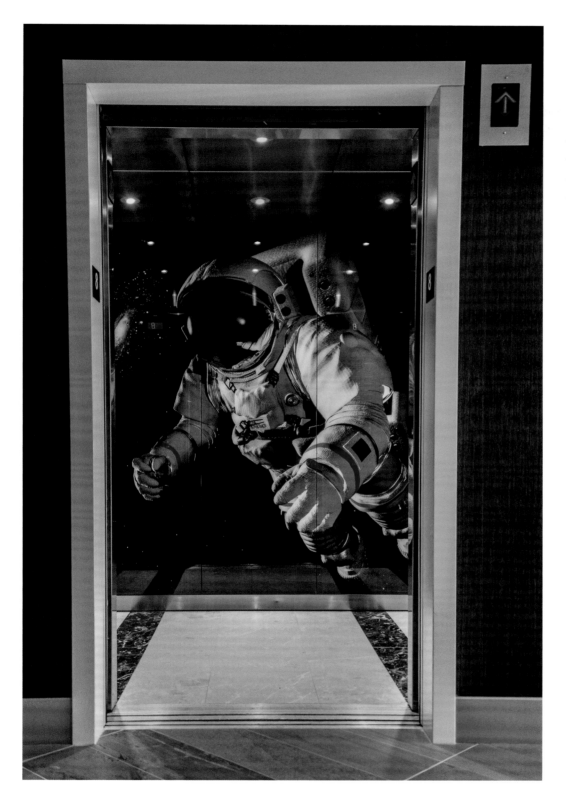

Houston, we have lift-off. Guests at the Marriott Marquis Hotel in downtown Houston are reminded of Houston's connections to the US space program on every elevator ride they take in the twenty-nine-floor hotel. At the back of each elevator are mural-like images of astronauts floating in space.

And the cow jumped over the moon. Visitors to Terminal A at George Bush Intercontinental Airport are greeted by "Moonwalker." The sculpture was donated to the city by Marc Ostrofsky, who described it as "a merging of the arts with aeronautics that depicts Houston's spirit of mingling creativity with opportunity." The airport's Terminals A and B opened a month before the historic Apollo 11 lunar landing in July 1969.

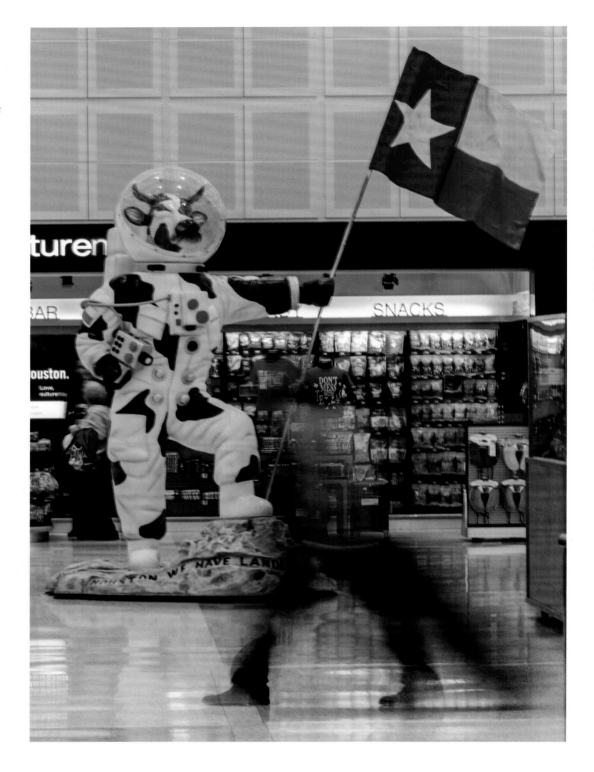

Light Spikes light up Bush Airport. The illuminated sculpture "Light Spikes" that lights up the area near the entrance to Terminals D and E at Bush Airport were originally commissioned for the 1990 Economic Summit of Industrialized Nations when it was hosted in Houston by President George H. W. Bush.

Portrait of an American space hero. In addition to being one of the original Mercury 7 astronauts, John Glenn was the first American to orbit Earth in 1962. He became the oldest person to fly in space—at the age of 77—as a crewmember of the Discovery STS-95 shuttle mission in 1998. In 2012, Houston honored Glenn with the John H. Glenn Jr. Panel, a two-dimensional visual display in Gragg Park, which is at the site of the first temporary NASA Manned Spacecraft Center offices.

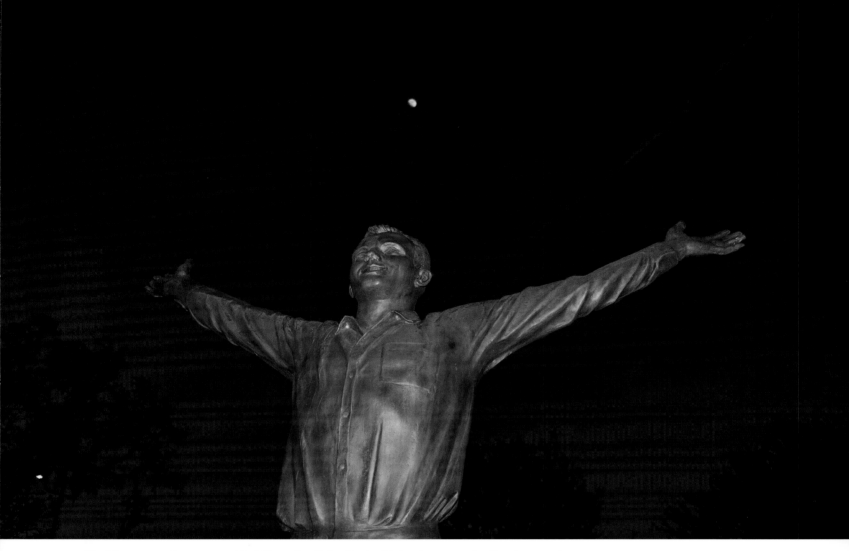

First in space. Cosmonaut Yuri Gagarin of the Soviet Union became the first human in space and the first to orbit Earth on April 12, 1961. Recognized in the former Soviet Union as a national hero, he is remembered today at Gragg Park.

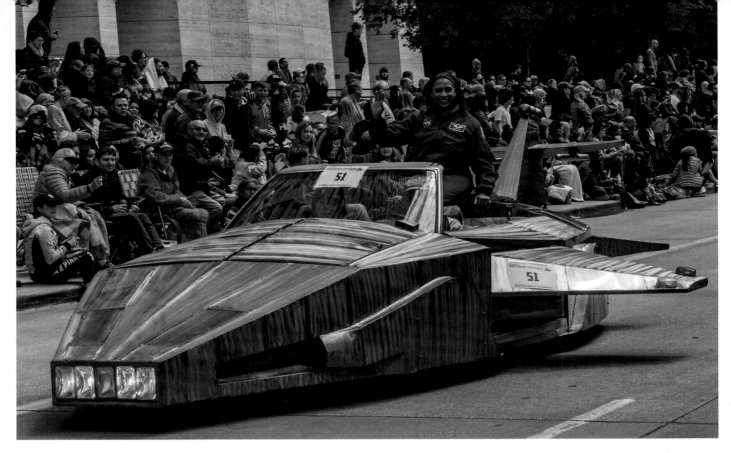

Car culture as art. NASA astronaut Jeanette Epps rode in the jet car as grand marshal for the 2018 Art Car Parade through downtown Houston. Since 1988 car-crazy Houston has hosted the annual Art Car Parade featuring hundreds of cars—and other types of rolling art—that reflect the personal views and visions of their owners, including several with a space-age theme. The jet car can also regularly be found on display at the ArtCar Museum (also called the "Garage Mahal") in the Heights area of Houston.

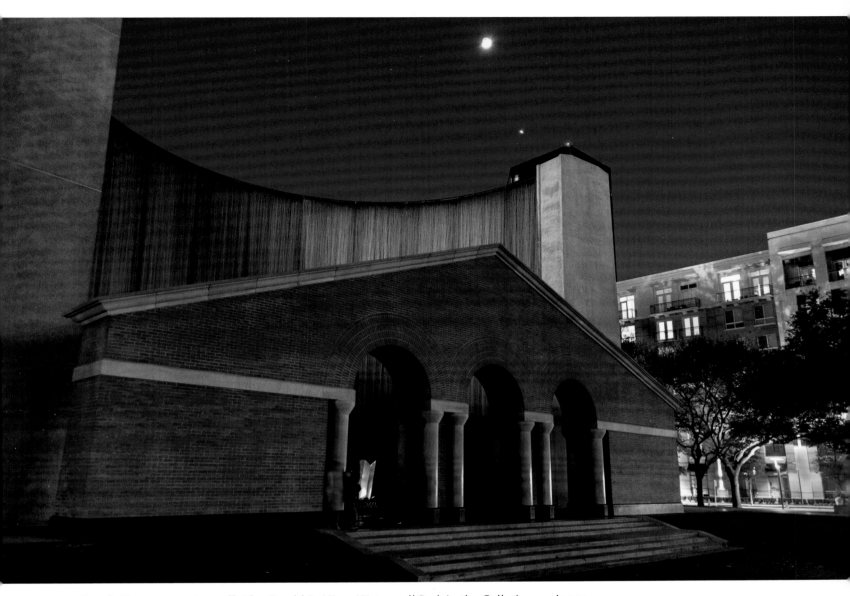

Iconic Houston waterwall. The Gerald D. Hines Waterwall Park in the Galleria area is one of the most photographed settings in Houston. The park features a sixty-four-foot semi-circular architectural fountain that circulates eleven thousand gallons of water per minute as it cascades down the structure's inner and outer walls. It opened in 1983 as a privately owned park but was acquired by the City of Houston in 2008 as a public park.

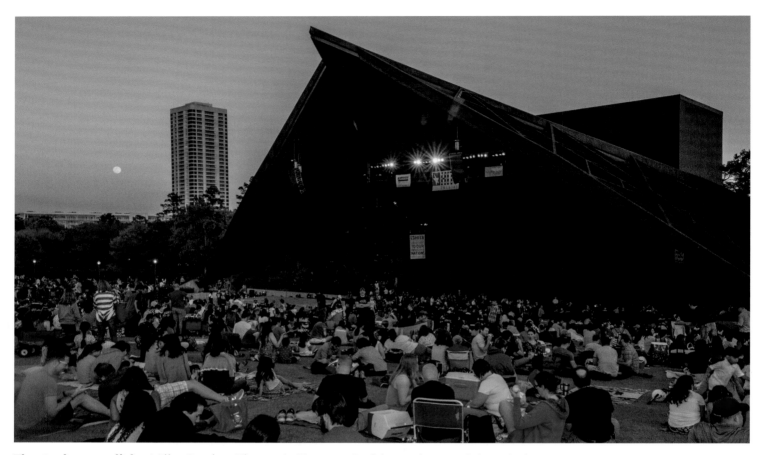

Theater by moonlight. Miller Outdoor Theater in Hermann Park hosts dozens of theatrical productions each year, including its annual Houston Shakespeare festival.

"What do you want? You want the moon? Just say the word and I'll throw a lasso around it and pull it down. Hey. That's a pretty good idea. I'll give you the moon, Mary."

—George Bailey, *It's a Wonderful Life*

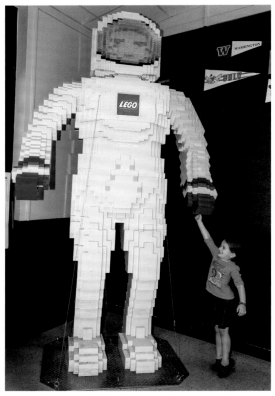

Inspired by space. It's never too early to dream about becoming an astronaut and exploring space, especially in Houston where images of space can easily be found around town, from the mural outside Texas Art Supply in the Montrose area to the super-sized Lego astronaut greeting students at Garden Oaks Montessori. And there's no better book to read (again and again) before bedtime than *Goodnight Moon*.

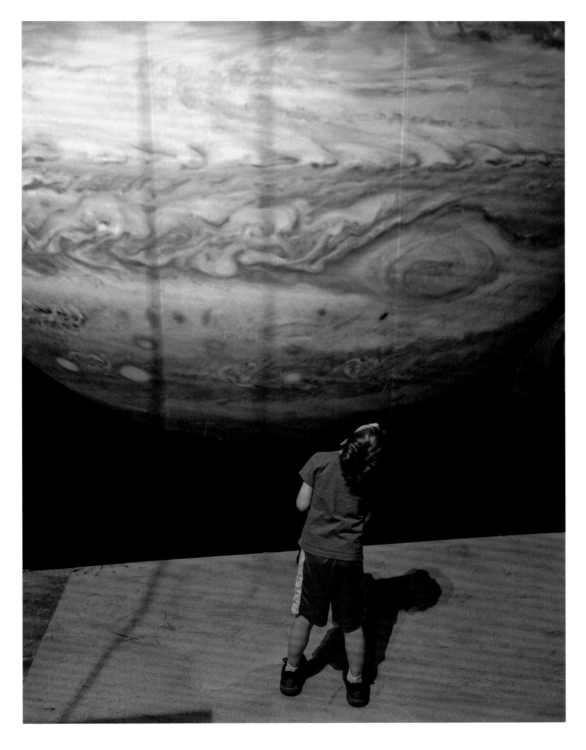

Mesmerized by Jupiter.
Among the many displays at the Houston Museum of Natural Science in Sugar Land is a mural of the solar system with each planet drawn to scale. Discovering the relative size of Jupiter compared with our home on planet Earth can be mind-boggling for explorers young and old alike.

A monument to Texas independence. The State of Texas and the City of Houston owe their very existence to the eighteen-minute battle of San Jacinto on April 21, 1836, during which the Texian Army led by General Sam Houston defeated the Mexican Army of General Antonio Lopez de Santa Anna. To commemorate the centennial of the victory, the state built the San Jacinto Monument, topped with a thirty-four-foot Lone Star—the symbol of Texas.

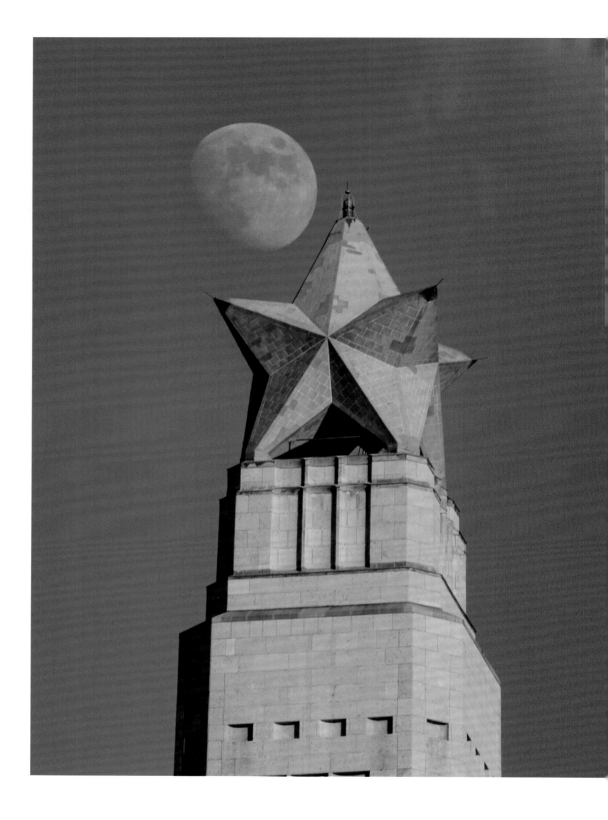

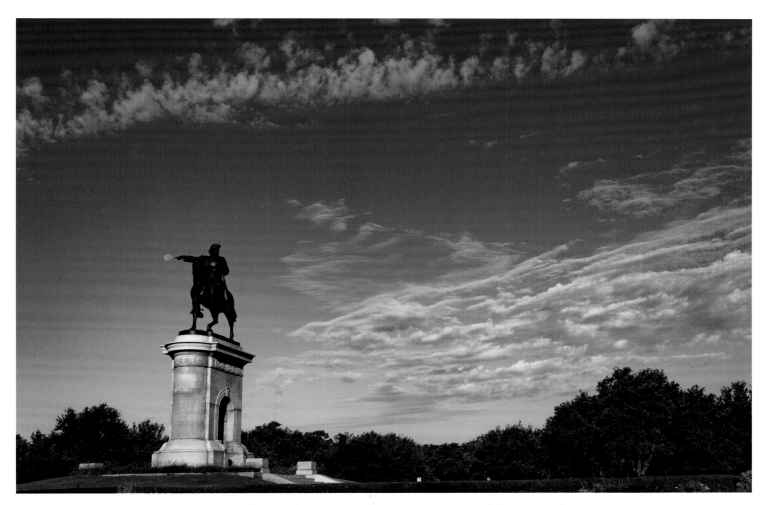

From the fields of San Jacinto to the plains on the moon. Following Sam Houston's victory at the battle of San Jacinto in 1836, the newly formed city was named in his honor. One hundred thirty-three years later, Houston became the first word from the moon when Apollo 11 landed on the moon. The Johnson Space Center is located about thirteen miles due south of the fields of San Jacinto.

Crown jewel. Visible for miles along Interstate 10 in west Houston, the Memorial Hermann Memorial City Hospital features a distinctive architectural crown on the top six floors.

Twin peaks. When they opened in 1991, the twin octagonal towers of the St. Luke's Medical Tower became an instant landmark in the Texas Medical Center in Houston, with their spires resembling twin syringes ready for injections.

Heavenly brew. Alcohol is actually allowed on the space station, but only if it arrives in the form of a science experiment. One of these experiments included attempting to brew beer in space. Some brewers have tried brewing beer with yeast or barley that has spent time in space. St. Arnold's Brewery in Houston brews only terrestrial forms of its popular beers—though sometimes under moonlight.

Hard Rock. Sporting a thirty-five-foot replica of Texas native Stevie Ray Vaughan's Gibson Firebird guitar, the Hard Rock Café is located in the former Albert Thomas Convention Center.

One wild ride. While it can't compare to a real rocket ride, the Iron Shark Rollercoaster at Galveston's Pleasure Pier provides riders with a thrilling, heart-stopping experience. There's no turning back once a rider reaches the top. After that, it's a one hundred-foot vertical drop at speeds reaching more than fifty miles per hour. Then it's a 1,246-foot coaster ride with a diving loop and four full inversions.

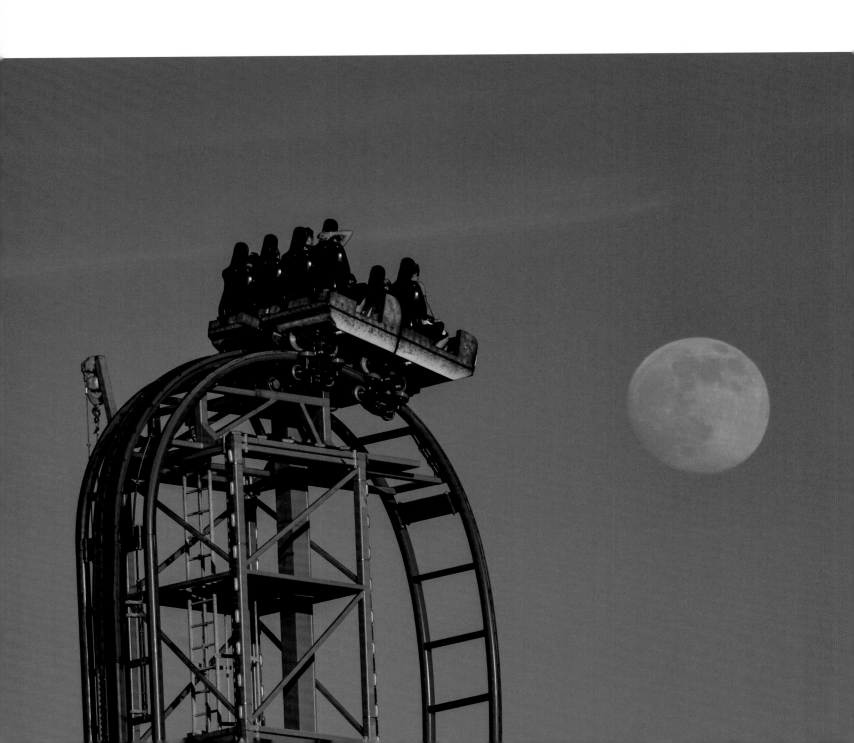

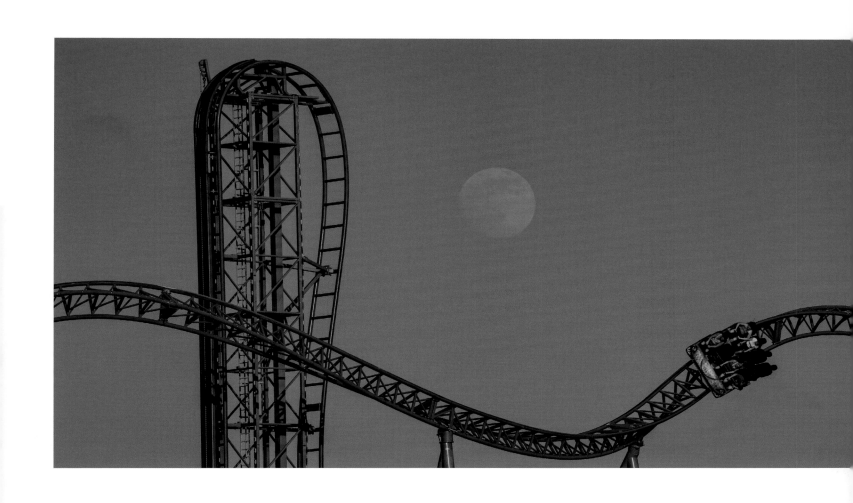

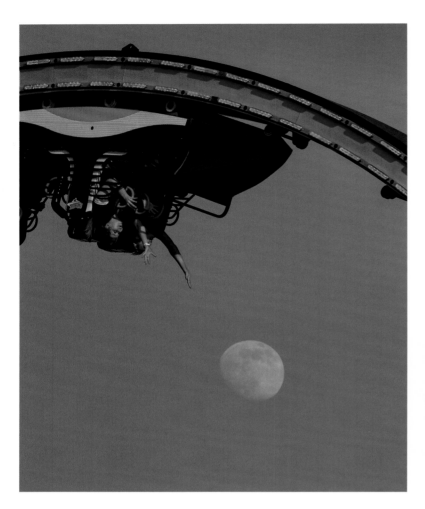

Try to catch the moon. Riders on the Cyclone at Pleasure Pier reach speeds of twenty-five miles per hour as they circle around on the sixty-foot tall looping roller coaster. And then they do it backward.

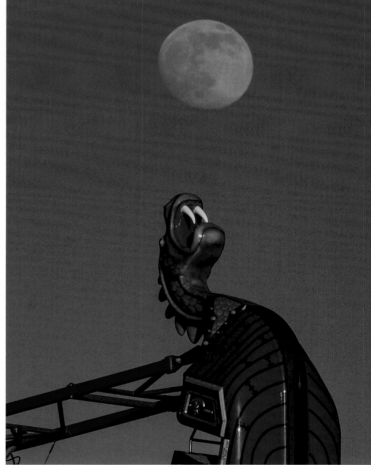

Here be dragons. Dragons are mentioned in myriad mythologies around the world. The Chinese dragon has long been a potent symbol of auspicious power in Chinese folklore. At Pleasure Pier on Galveston's Seawall the flying Sea Dragon uses the powers of speed and g-forces to create fear among riders.

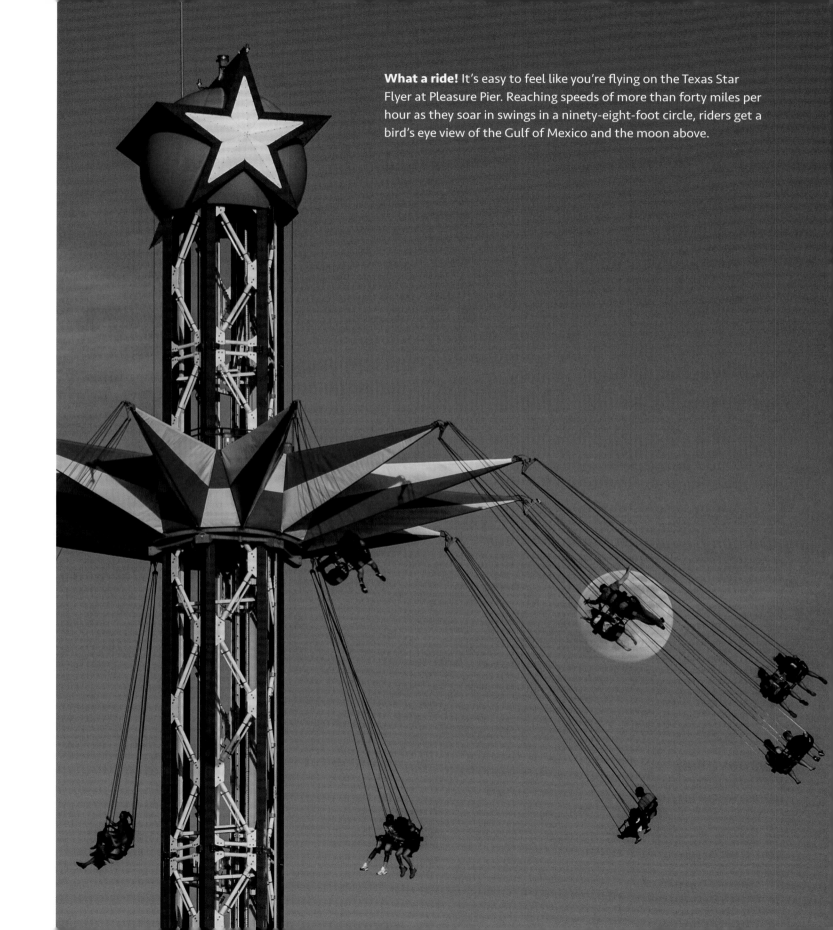

What a ride! It's easy to feel like you're flying on the Texas Star Flyer at Pleasure Pier. Reaching speeds of more than forty miles per hour as they soar in swings in a ninety-eight-foot circle, riders get a bird's eye view of the Gulf of Mexico and the moon above.

Beam me up. When it opened in 1983, the sixty-four-story Williams Tower in the Galleria area quickly became an iconic Houston landmark. At the time, it was also said to be the world's tallest office building outside a central business district. The tower boasts a seven thousand-watt beacon that sweeps across the sky and can be seen up to forty miles away on a clear night.

A welcome sign. Drivers are greeted with a large welcome sign and the Lone Star of Texas as they enter downtown Houston on Smith Street.

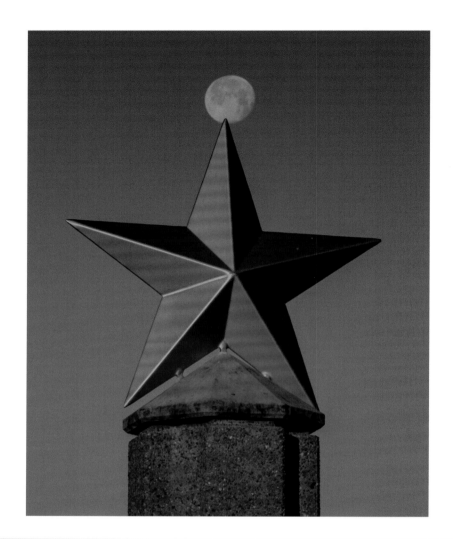

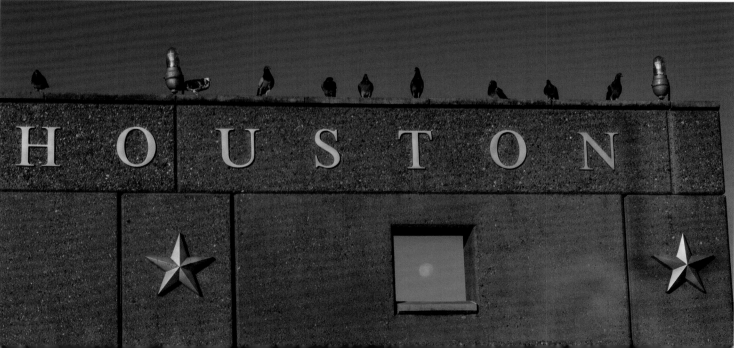

Lone Star, Full Moon. The state of Texas has played an integral role in the US space program. In addition to the home of NASA's Johnson Space Center, a number of astronauts hail originally from the Lone Star state and many Texas colleges, universities, research institutions, and companies have contributed to the space program over the past decades.

Pumped up. While Johnson Space Center has helped to diversify Houston's economy for more than fifty years, the energy industry continues to be the primary economic pump for the region. Pump jacks and drilling rigs can still be found throughout the area while offshore drilling rigs are often brought to Galveston for repairs and maintenance.

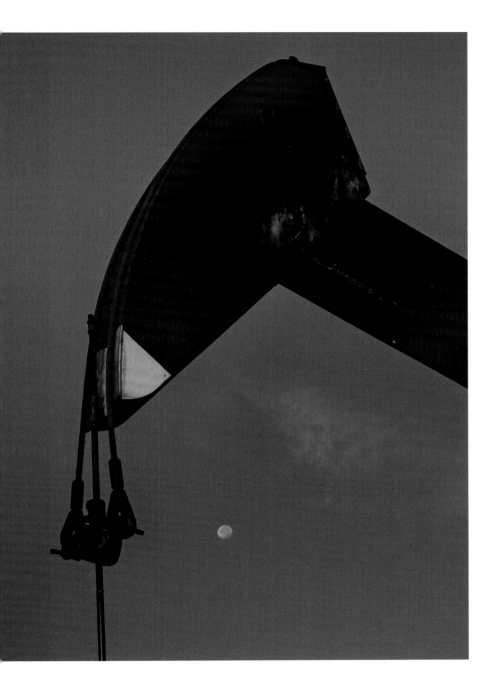

Still in the frontier business. During the economic recessions of the 1980s, Texas used a space theme and the state's legacy of exploring new frontiers as part of a marketing program to promote its efforts to diversify the state's economy.

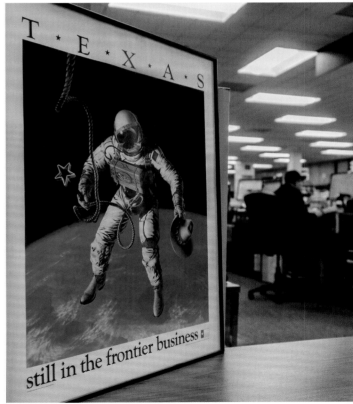

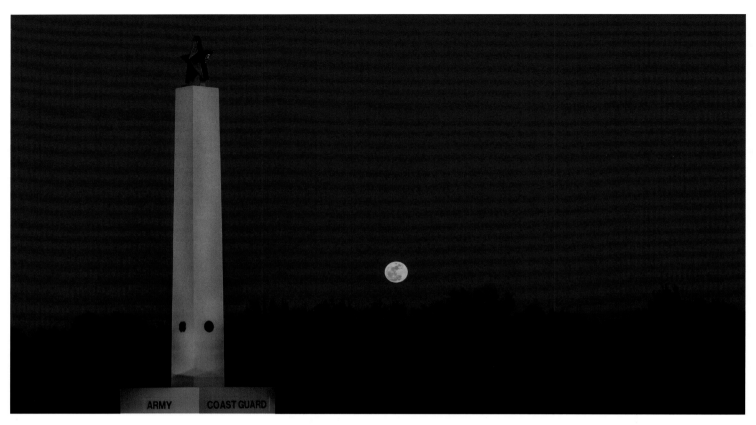

Honoring America's Armed Forces. Freedom Park, located in George H. W. Bush Park in far west Houston, honors each branch of America's Armed Forces. The monument, capped by the Texas Lone Star, is similar in design to the historic San Jacinto Monument east of Houston.

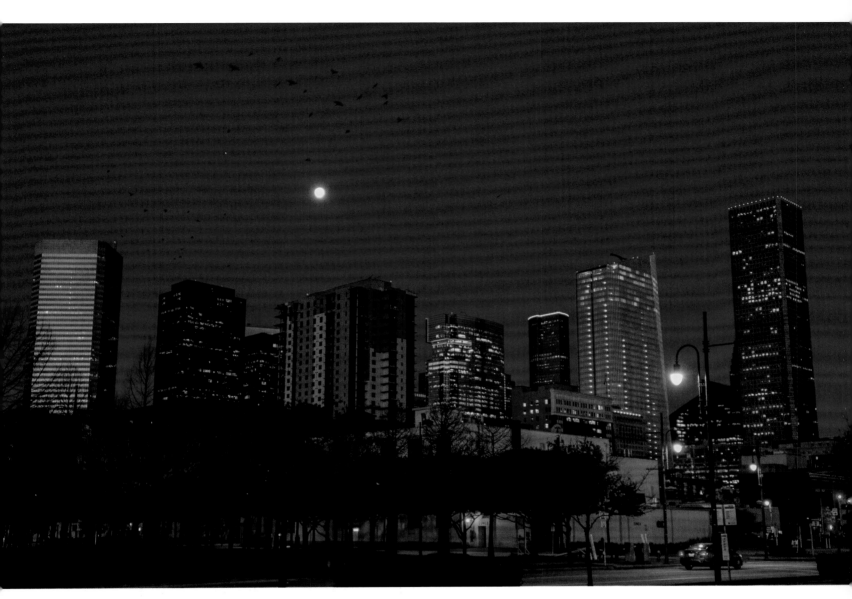

Moonset over downtown Houston. While most photographs of Houston's skyline are taken from the west side of downtown along Buffalo Bayou, the east-facing side of downtown Houston is equally attractive.

Redefining rush hour.
In 1969, Harris County boasted 298 miles of freeways and almost one million registered vehicles. By 2016, the nine-county greater Houston area had more than five million registered vehicles traveling on more than 4,200 lane miles of freeways.

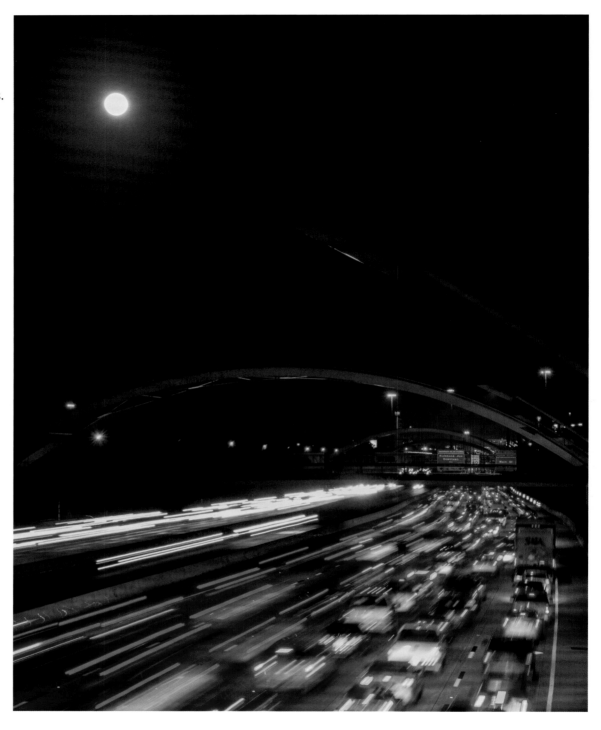

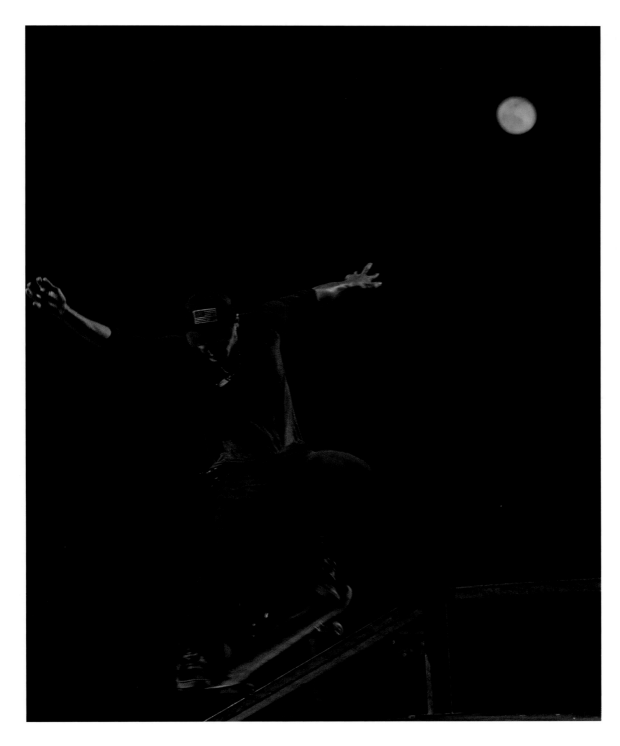

Dancing with a skateboard. Houston is home to several skateboard parks where enthusiasts can perfect their moves throughout the day—and by moonlight.

Hiding in plain sight. With the development of highly sophisticated pulse Doppler antennae to detect high-intensity weather conditions came the need to protect that equipment from just the kind of severe weather that it is designed to monitor. The solution: geodesic radomes. Usually constructed of fiberglass, geodesic radomes provide a weatherproof enclosure that protects the equipment without interfering with the electromagnetic signals transmitted or received by the antenna within the structure.

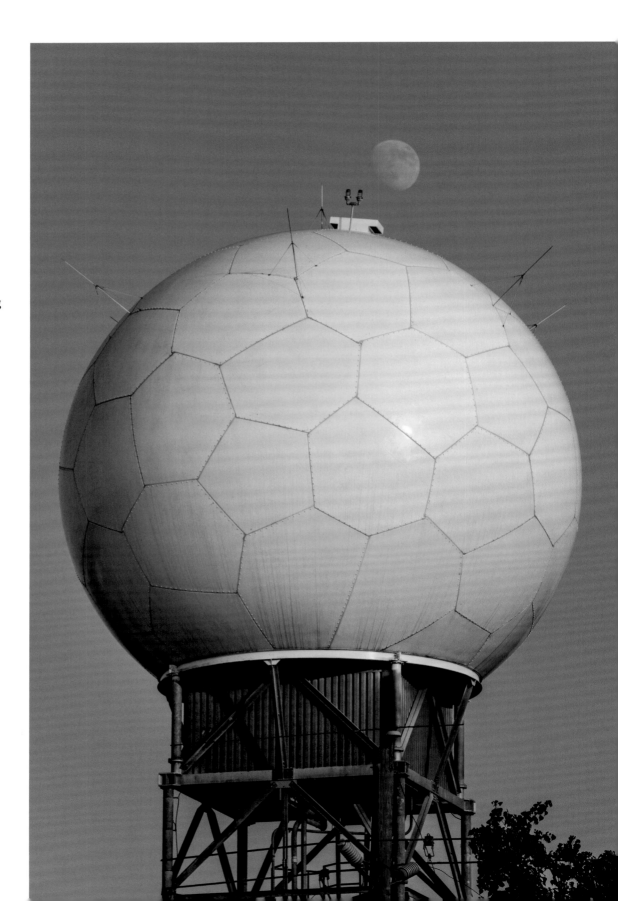

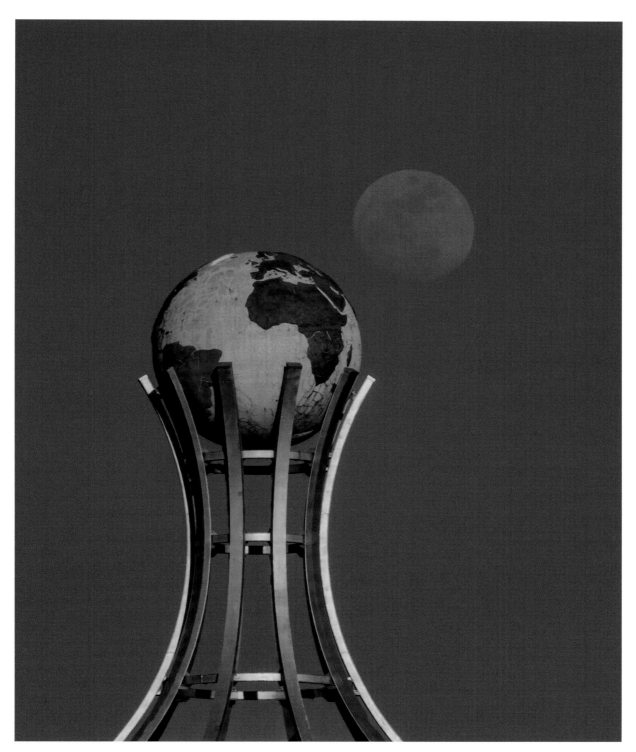

A world of harmony. The moon rises above a large globe erected atop
Harmony Public Schools' office in far west Houston.

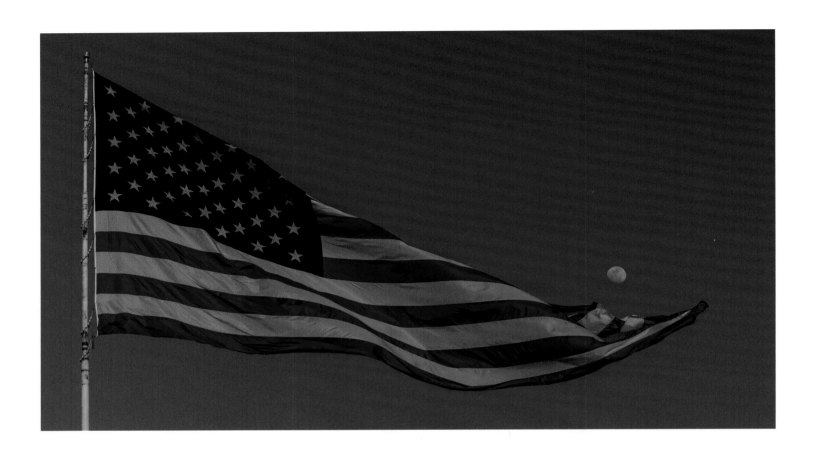

From now on we live in a world where man has walked on the moon. It's not a miracle; we just decided to go.

—Jim Lovell
Command module pilot, Apollo 8
Commander, Apollo 13

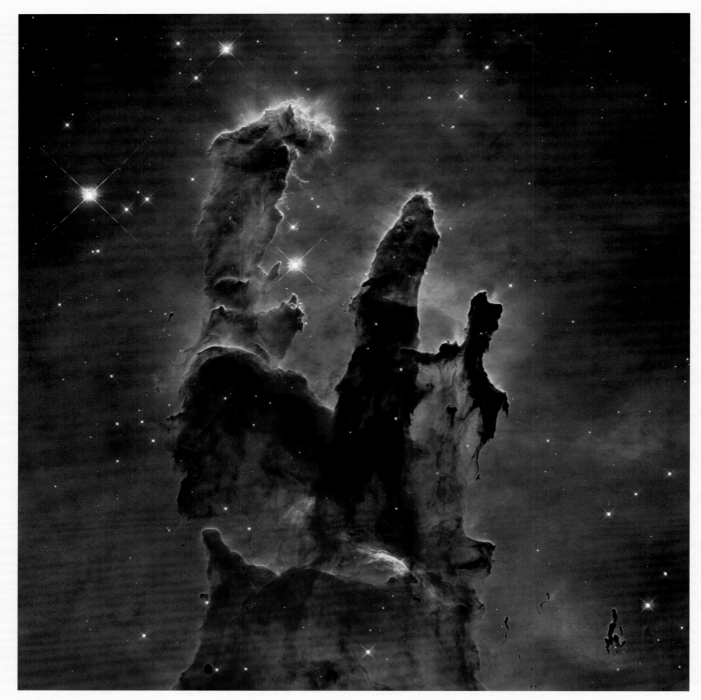

Pillars of Creation. Rice University alumni Jeff Hester and Paul Scowen were responsible for one of the most important and recognizable photographs from the Hubble Space Telescope. Pillars of Creation features trunks of interstellar gas and dust in the Eagle Nebula, some 6,500–7,000 light years from Earth. The image was selected by Time Magazine as one of the 100 most influential photographs in history. Photo courtesy of NASA

Chapter 3

Out of this World Research

Supporting NASA's Mission to Leverage
Space Technology "for all mankind"

Our decision is that this laboratory should be located at Houston, Texas, in close association with Rice University and the other educational institutions there and in that region.

—James E. Webb, NASA administrator
September 14, 1961, memo to President John F. Kennedy

From the early days of the US space program, the plan was that strong educational institutions would play a pivotal role in the program's success. In his memo to President John F. Kennedy recommending Houston for the Manned Spacecraft Center, NASA administrator James Webb noted that the agency was strongly interested in collaborating with educational institutions in the region, including Rice University, the University of Houston, Baylor College of Medicine, and others. Over the years, the Johnson Space Center has managed numerous research programs at Texas universities and institutions. In 2016, for example, JSC was responsible for more than $18 million in university research programs as well as almost $12 million in Small Business Innovative Research grants.

Rice University

In addition to its role in facilitating the donation of land to NASA for the new Manned Spacecraft Center, Rice University had much else to offer NASA in academic support for its researchers, scientists and engineers. Kennedy even said as much in his speech at Rice University on September 12, 1962, noting that "the growth of our science and education will be enriched by new knowledge of our universe and environment, by new techniques of learning and mapping and observation, by new tools and computers for industry, medicine, the home as well as the school. Technical institutions, such as Rice, will reap the harvest of these gains."

In 1961—almost fifty years after its founding—Rice was already recognized around the country for its strong academic programs in engineering and materials research. In January 1963, Rice followed up on its initial commitment to NASA by creating the first department of space science in any US college or university. The department offered graduate programs leading to master's and doctorate degrees. Later that year, the university established a satellite techniques laboratory to serve as the basis for the design, construction, checkout, and environmental testing of individual instruments and complete payloads. The lab housed a telemetry management and command station and equipment to analyze data received from satellites in addition to design and fabrication equipment. Three years later, Rice also opened a NASA-funded space science building on campus.

Since then, Rice has participated in numerous NASA-funded space-related research projects. And its graduates have gone on to become astronauts, scientists, and physicists who have

achieved worldwide acclaim. The Rice Space Institute, founded in 2000, continues to foster space-related programs both with other Rice University academic areas as well as with NASA and other universities and research organizations.

Highlights of Rice's partnership with NASA include:

- Fourteen astronauts have either taught or studied at Rice University, including Peggy Whitson '85 (PhD), who served as the first female commander of the International Space Station and holds the record for most total days spent in space by any NASA astronaut.

- Of the two experiments deployed by the Apollo 11 crew on the lunar surface, one was designed, built, and tested at Rice.

- In November 1969, Apollo 12 carried the first Apollo Lunar Surface Experiments Package (ALSEP). The package included two experiments designed at Rice to measure particles from solar wind.

- The Suprathermal Ion Detector Experiment (SIDE) flew on Apollo 12, 14, and 15. It returned data from each site for about two years. The experiment was the first to detect water vapor on the moon and made possible a series of groundbreaking findings about the composition and nature of the earth's magnetosphere.

University of Houston

The University of Houston began offering selected graduate courses at NASA's temporary offices in Houston in the fall of 1964, which addressed NASA's need and interest in advanced academic and professional programs to support its growing workforce. In the first year, more than five hundred NASA employees enrolled in graduate and undergraduate courses at the University of Houston, including programs in physics, math, and engineering.

Over the years, UH has conducted space-related research in a variety of programs, including space architecture, health and human performance, space life sciences, advanced materials, and other areas. The Sasakawa International Center for Space Architecture, for example, has researched requirements for human orbital and planetary missions, including concepts for habitats, structures, and support systems. More recently, the center has done similar studies involving extreme environments on Earth. Founded in 1987, the center offers the world's only master's degree program in space architecture. And, during the shuttle era, Alex Ignatiev led the University of Houston Space Vacuum Epitaxy Center and was principal investigator for the Wake Shield Facility program that grew high-purity epitaxial semiconductor films during three flights on the shuttle.

As a result of its novel research, UH created the University of Houston Center for Advanced Materials. Since then, the center has successfully transferred its basic and applied research into the private sector through the formation of at least six spin-off companies.

UH's department of health and human performance has conducted research on changes in astronaut muscle strength and function during extended space flights. The goal is to understand health risks for any potential flight to Mars since space station crewmembers lose about ten percent of muscle strength on typical missions lasting four to six months.

The NASA-UH partnership even led to the creation of another UH campus. In the 1960s, Robert Gilruth, then-director of the Manned Spacecraft Center, formally requested "that the University of Houston give immediate consideration to the establishment of a permanent graduate and undergraduate educational facility in the Clear Lake area." Gilruth noted that "the availability of the best educational opportunities for our employees is vital to the accomplishment of our Center's mission objectives."

The university responded by creating the University of Houston–Clear Lake. The new school held its first classes in the Clear Lake area in January 1973.

Baylor College of Medicine

Baylor College of Medicine has had a long association with the Johnson Space Center and has often been ranked as the top NASA-funded life science research and development program in the country. In 2008, Baylor established the Center for Space Medicine, the first department or academic center in space medicine ever established in a university or medical school. The center also has become the academic home to all physician-astronauts and physician-cosmonauts in the world.

The center's research efforts focus on issues related to human adaptation to space as well as the health and medical care of astronauts. Researchers, for example, have investigated new syndromes that had not been previously recognized, including changes to an astronaut's vision and other effects on the nervous system. The research also focuses on how to protect astronauts from the harsh environment induced by radiation in space, which could affect the heart, coronary arteries, and the brain.

Baylor also has led the National Space Biomedical Research Institute (NSBRI), created by NASA in 1997. Together with other national and Houston-area institutions, including Rice University and Texas A&M University, the NSBRI conducted research aimed at both assuring the safe human exploration of space and exploring ways to apply the resulting advances on Earth. The consortium's research focused on a variety of health issues, including bone loss, cardiovascular issues, immunology, muscle changes, radiation effects, neurobehavioral and psychosocial factors, nutrition, physical fitness and rehabilitation, and smart medical systems. The NASA cooperative agreement for NSBRI ended in 2017.

In 2016, Baylor's collaboration with NASA was expanded again with a six-year cooperative agreement to manage the NASA Translational Research Institute, focused on finding new ideas and health treatments for long-duration space flight missions, including a potential journey

to Mars. The NASA cooperative agreement could be extended to twelve years, covering the potential operational life of the International Space Station.

For heart patients, one of the most dramatic examples of space technology transfer involves a unique collaboration between NASA, famed Baylor College of Medicine heart surgeons Dr. Michael DeBakey and Dr. George Noon, and MicroMed Technology Inc. on a life-saving heart pump for patients awaiting transplants. The resulting MicroMed DeBakey VAD device functions as a "bridge to heart transplant" by pumping blood throughout the body to keep critically ill patients alive until a donor heart is available. Based on initial designs by De-Bakey and Noon, NASA teams then applied their knowledge and experience with simulating fluid flow through rocket engines. They then used NASA supercomputers and computational fluid dynamics technology to model and analyze blood flow through the battery-powered heart pump.

Looking for opportunities to further extend that same kind of collaboration and information-sharing among the space, medical, and energy industries, several institutions in Houston, including ExxonMobil Houston, Houston Methodist DeBakey Heart and Vascular Center, the University of Houston, and NASA have collaborated on the annual Pumps and Pipes Symposium. Since 2007, the event has brought together leading professionals and researchers in the energy, medicine, academic, and aerospace industries as well as venture capitalists, community leaders, and equipment manufacturers to exchange ideas and explore crossover technologies.

Texas A&M University

Texas A&M University's ties to NASA and the Johnson Space Center stretch from the early days of the space program through today's International Space Station. A&M established its aeronautical engineering department in 1940, and it changed its name to aerospace engineering in 1963 to broaden the scope of the program to include astronautics to help meet the needs of the growing US space program. Today, the department includes more than twenty facilities and centers on campus, ranging from materials testing labs to space robotics laboratories. The department's curriculum includes the three principle disciplines of aerospace engineering: aerodynamics and propulsion, dynamics and control, and materials and structures. Graduates have gone on to work for NASA as well as SpaceX, Blue Origin, and other leading aerospace companies.

A&M's connections to NASA also leverage the university's agricultural roots. Working with researchers from JSC and the university's National Center for Electron Beam Research, for example, the A&M AgriLife research program developed and prepared more than thirty ready-to-eat foods at its space food research facility for the International Space Station.

Separately, students in the A&M electronic systems engineering technology program have worked with JSC engineers to develop space-qualified hardware systems. The goal is to devel-

op small, reconfigurable computer systems that can be easily adapted to different applications, including spacecraft instrumentation and control systems.

Texas Southern University

Texas Southern University's work with NASA includes the development of the University Research-1 payload that was launched aboard the SpaceX Dragon spacecraft to the International Space Station. The experiment involved investigating drug countermeasures to mitigate the adverse effects of space flight and radiation on the immune system.

In 2008, TSU established the Center for Bionanotechnology and Environmental Research to design countermeasures to mitigate the risks associated with environmental hazards that astronauts encounter in space. The center also provides training opportunities for students, postdoctoral fellows, and faculty.

The University of Texas Medical Branch–Galveston

Through a partnership with the Johnson Space Center, the University of Texas Medical Branch (UTMB) at Galveston offers the only aerospace and internal medicine combined medical residency program in the United States. The program trains students in the physical and engineering aspects of the flight environment with a focus on the physiology of high-G stress, hyper- and hypobaric environments, and radiation exposure. It also addresses unique aspects of space medicine applications, like medical standards and certification, crew health issues, biomedical protective equipment, radiation, remote monitoring, and lifetime surveillance of astronaut health.

UTMB is also the home to an extensive collection of papers, magazines, and articles chronicling the development of space travel and medicine. The Charles A. Berry History of Space Medical Collection at the Moody Medical Library Space Medicine Collection is named after Charles A. Berry, MD, who served as the university's first chair of aerospace medicine after serving as director of medical operations and research at the then-Manned Spacecraft Center during the Gemini and Apollo programs.

Houston Methodist Research Institute

The Houston Methodist Research Institute uses one of the largest scientific labs in the world to conduct research on the smallest level. The institute plans to send eight nanoscale experiments to the International Space Station by 2021. Led by Alessandro Grattoni, the Houston Methodist center focuses on the development and testing of technologies in four areas—diagnostic and therapeutic biomedical devices for precision medicine, nanotherapeutics for targeted drug delivery, regenerative medicine, and tissue engineering.

The first microgravity experiment to study the diffusion of drug-like particles was flown to the space station aboard a SpaceX vehicle. The project focuses on mimicking the diffusion of

drug molecules in nanochannels on a larger scale by adopting microparticles in microchannels (two to eight micrometers), where their movement will not be influenced by gravity, and their larger size will enable visualization through microscopes.

The Methodist Center of Space Nanomedicine also is engaged in research on the International Space Station involving a remotely controlled drug delivery implant, lung regeneration, and an implantable nanochannel system for delivering drugs to counter muscle atrophy. Ultimately, researchers hope to improve implantable devices that release pharmaceutical drugs at a steady rate for patients on Earth.

International Space Station

The International Space Station has often been characterized as a giant laboratory in space. In 2005, the US officially recognized its status by designating the US segment of the space station as a national laboratory. In the process, NASA was directed to develop a plan to increase the utilization of the International Space Station by both other federal entities and the private sector in the pursuit of national priorities for the advancement of science, technology, engineering, and mathematics as well as for the exploration and economic development of space.

"For all mankind"

Transferring technology from space to applications on Earth has been incorporated into NASA's mission since its founding. In fact, the National Aeronautics and Space Act of 1958 that created the space agency stipulates the agency's mission to not only explore the universe and advance aeronautics but also to transfer its technologies "for the benefit of all mankind."

Since NASA's creation, technologies developed to advance NASA missions have found secondary applications, leading to products, services, and processes that create jobs, generate profits, improve efficiencies, and even save and improve lives. While there are challenges in documenting all of the technology transfer applications, NASA's technology transfer magazine, *Spinoff*, has profiled more than two thousand spinoffs since it was first published in 1976.

Nurturing space technology transfer

To identify and promote secondary uses for its technologies, NASA created technology transfer and commercialization offices at each of its centers. At the Johnson Space Center, the office facilitates the transfer and commercialization of NASA-sponsored research and technology as well as the use of JSC's unique research and development capabilities and facilities. The office has worked with hundreds of entrepreneurs, companies, and investors to help them license NASA-developed technologies that they can then bring to the marketplace.

Researchers at the Johnson Space Center, for example, have worked in collaboration with General Motors and Oceaneering to design a state-of-the-art, highly dexterous, humanoid robot: Robonaut 2 (R2). R2 is made of multiple component technologies and systems—vision

systems, image recognition systems, sensor integrations, tendon hands, control algorithms, and much more. R2's nearly fifty patented and patent-pending technologies have the potential to be game-changers in multiple industries, including logistics and distribution, medical and industrial robotics, and hazardous, toxic, or remote environments.

Home of new space companies

The Houston area also has nurtured a number of space-related "home town" companies.

NanoRacks, based in Webster, transports scientific payloads to the International Space Station and maintains a permanent laboratory named NanoLabs aboard the space station. NanoRacks also has an agreement with Blue Origin to offer business development services for the company's New Shepard Suborbital Vehicle. Since its founding in 2009, NanoRacks has deployed more than three hundred payloads to the International Space Station. When the company's CubeSat Deployer was launched in January 2014 on the Orbital Sciences Cygnus Orb-1 mission, it became the first commercial platform to deploy satellites from the International Space Station. It has since deployed more than 150 satellites into lower Earth orbit, with an order backlog of more than one hundred.

Another Webster-based company, Ad Astra Plasma Rocket Company, was founded by former astronaut Franklin Chang Díaz, inventor of the Variable Specific Impulse Magnetoplasma Rocket. Chang Díaz, a veteran of seven space shuttle missions, credits his years as an astronaut to inspiring his concepts for transforming space transportation and exploration. As part of a program to develop the next generation of in-space propulsion systems, NASA awarded Chang Díaz's company a three-year, $9 million contract in 2015.

Space Spinoffs

Technology first created or adapted for space applications—including many developed at Johnson Space Center—have changed our lives on Earth.

Consumer products

A variety of consumer products owe their existence to research first conducted by NASA, including satellite television, hand-held cordless vacuum cleaners, scratch-resistant sunglasses, sports apparel, car seats, and hairstyling equipment.

Sports and exercise products

NASA technology has improved performance and safety in several sports areas, including air-cushioned running shoes, recovery blankets for long distance runners, aerodynamic swimsuits, reinforced graphite used in tennis rackets and race cars, and fog-resistant eyeglasses and goggles for skiers, scuba masks, and car windows.

Public safety

Our lives—as well as those of first responders—have been made safer today thanks to NASA technology that can now be found in the fire-retardant suits and breathing apparatus of firefighters, medical equipment used by first responders, equipment used to free victims from car crashes, and technology and better brakes for passenger cars, trucks, and buses.

Health and medicine

When Alan Shepard was preparing to become the first American to fly in space, NASA scientists had to invent an automatic measuring device to find out how blasting off affected the astronaut's blood pressure. Blood pressure kits based on this design subsequently went mainstream. Since that historic flight, NASA researchers have developed and refined a number of technologies that help us live healthier lives today. The list includes laser technology used in heart surgery, artificial and robotic limbs, dietary supplements, and antigravity treadmills for orthopedic rehabilitation.

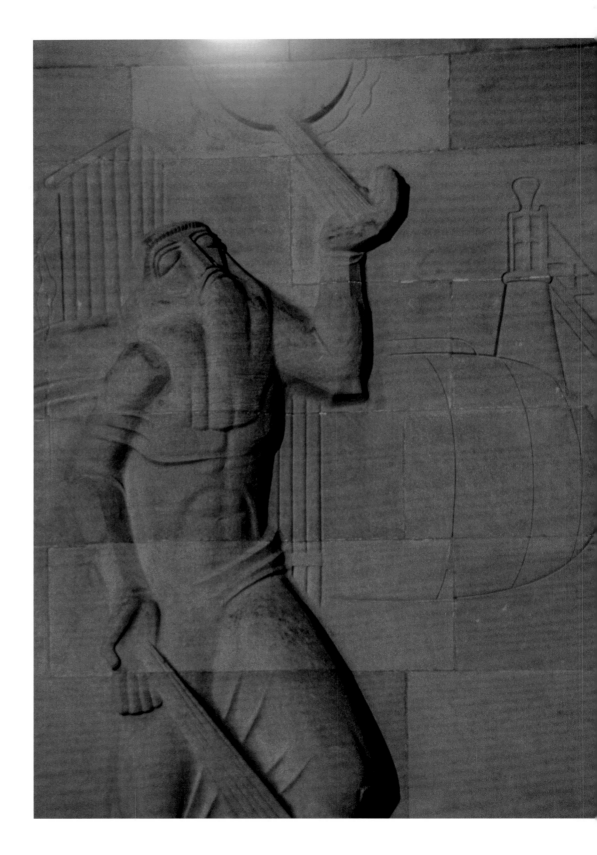

Harnessing the power of knowledge. The upraised hand of the figure on the façade of Rice University's Abercrombie Engineering Laboratory seems to capture and transfer the power of the sunlight striking it. The building houses several of Rice's engineering programs.

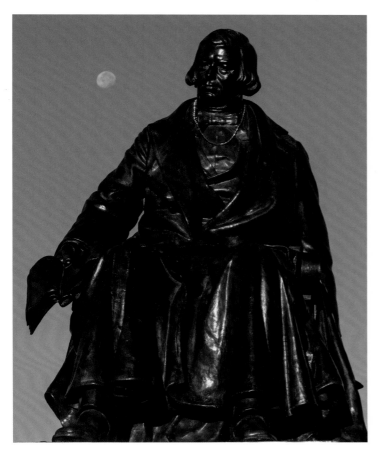

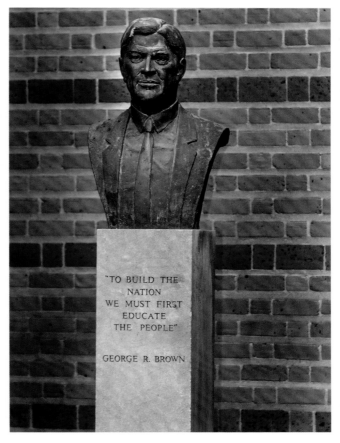

"Hail forever, and forever hail!" The memorial to university founder William Marsh Rice is affectionately known on campus as "Willy's statue" and is often the object of student pranks. On the face of the pedestal beneath the shield of the university, there is an inscription adapted from Virgil: "Hail forever, and forever hail!" to serve as a perennial greeting.

Forging a leadership role for Rice University. As member of the Board of Trustees of Rice University from 1943–67, George R. Brown pushed to make the university one of the top institutions in the country. During his lifetime and later through the Brown Foundation, he contributed millions to enhancing and expanding the university. Today, the Brown School of Engineering at Rice is rated one of the top undergraduate engineering schools in the country.

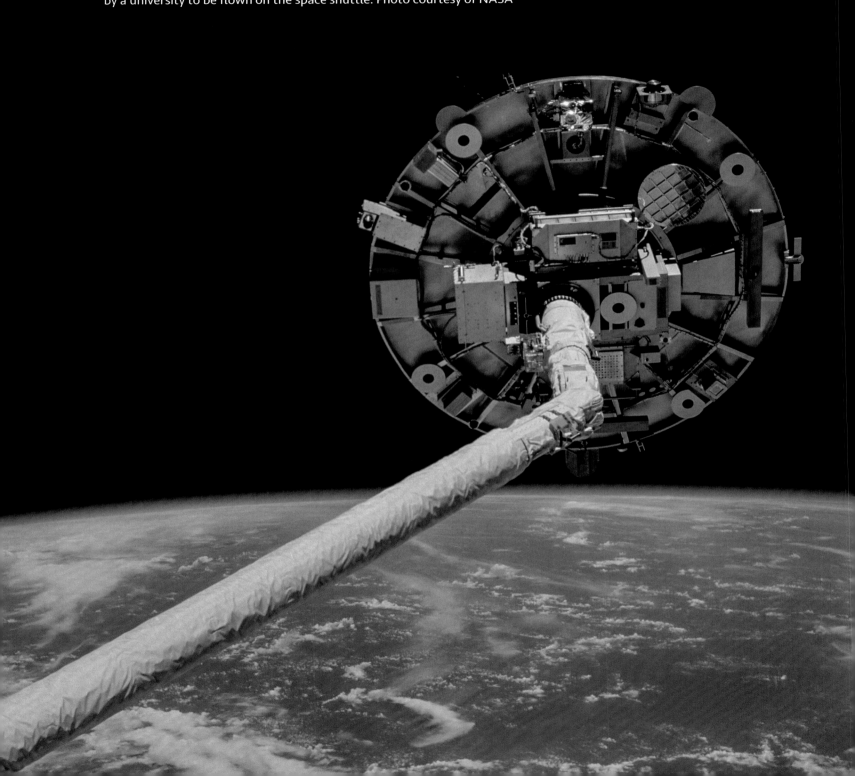

Thin films in space. During the shuttle era, Alex Ignatiev led the University of Houston Space Vacuum Epitaxy Center and was principal investigator for the Wake Shield Facility program that grew high-purity epitaxial semiconductor films during its three flights on the shuttle. It was the first principal research payload developed by a university to be flown on the space shuttle. Photo courtesy of NASA

Radiation buster. University of Houston physicist Lawrence Pinsky has led research in relativistic heavy ion physics. He began working with Johnson Space Center during the Apollo program as NASA began studying cosmic rays reported by astronauts on the moon. Pinsky pioneered the first radiation sensors installed on the International Space Station in 2012 and has developed active radiation monitors for testing on the Orion program.

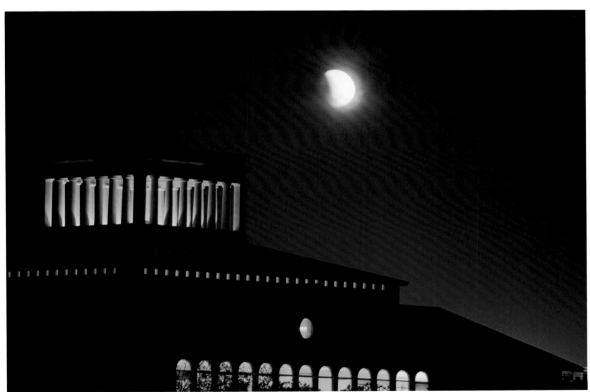

From classic architecture to space architecture. To get a glimpse of the future, architecture students at the University of Houston have an opportunity to enroll in the world's only master's degree program in space architecture. The Sasakawa International Center for Space Architecture at UH has researched requirements for human orbital and planetary missions, including concepts for habitats, structures, and support systems.

JSC History Vault. More than 160,000 documents covering the history of Johnson Space Center are archived at the University of Houston–Clear Lake JSC History Collection. As part of the archives, the Johnson Space Center Oral History Project includes more than 1,500 interviews with more than 900 managers, engineers, technicians, doctors, astronauts, and other NASA employees and contractors who served in key roles during the Mercury, Gemini, Apollo, Skylab, and Shuttle programs.

Cutting-edge research. Texas A&M is ranked among the top aerospace engineering programs in the United States in part for its cutting-edge educational and research programs like the Texas A&M University National Aerothermochemistry and Hypersonics Laboratory, funded in part by NASA. Texas A&M traces its aerospace roots to 1940 when it established its aeronautical engineering department.

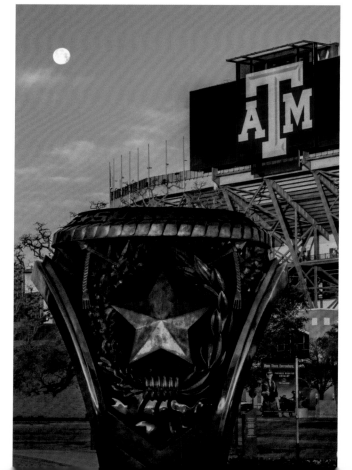

MinION tester. Spaceflight microbiologists at JSC helped develop a MinION sequencer so that astronauts on the International Space Station can sequence DNA and RNA in space. The technology, which some scientists consider a game changer, enables astronauts to more easily identify the microorganisms inhabiting the station and to understand how life adapts to the environment of space.

Nanoscale drug delivery. Researcher Alessandro Grattoni of the Houston Methodist Research Institute's Center of Space Nanomedicine is working with NASA to send eight nanoscale experiments to the International Space Station by 2021. The ultimate goal is to improve implantable devices that release pharmaceutical drugs at a steady rate.

NASA technology takes flight. The vertical tip at the end of an airplane wing is a called a winglet and was originally developed by NASA. The winglet is designed to produce forward thrust to help the plane in takeoff and flight, operating much like a boat sail to reduce wingtip drag. The winglets also reduce fuel consumption.

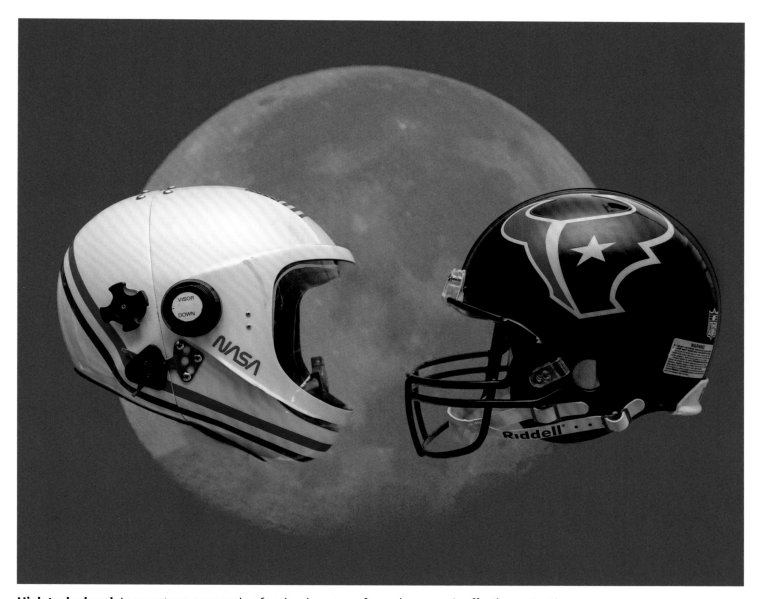

High tech ahead. In an extreme example of technology transfer and space spinoffs, the protective aspects of today's football helmets are a direct result of NASA research. NASA began research in the 1960s on protective padding for space helmets. The result was a foam product that takes the shape of an object and absorbs most of the shock. In addition to finding its way onto football fields, the padding also found applications on baseball chest pads, soccer shin guards, and airplane seats. Separately, the outside of some football helmets today are made from plastic first used in astronaut helmets. It helps reduce the impact of a tackle by distributing the force over more of the head.

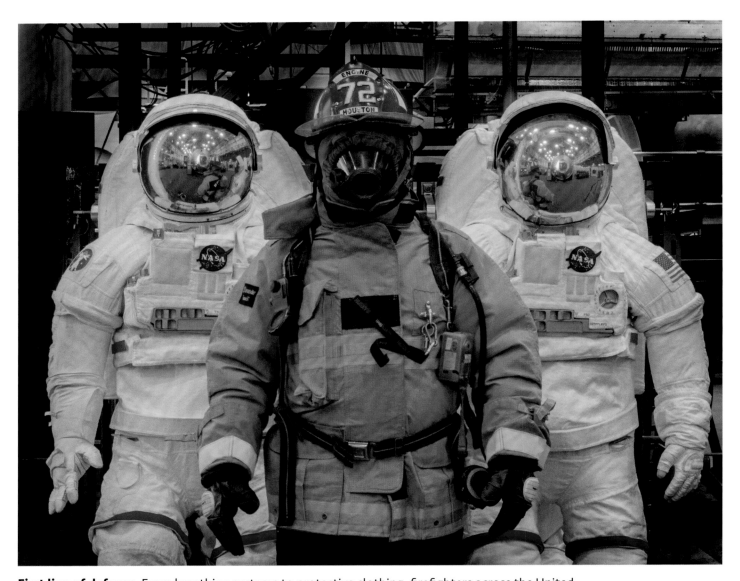

First line of defense. From breathing systems to protective clothing, firefighters across the United States are safer today in part due to NASA research and development of space suits. In the 1990s, NASA began working with the Houston Fire Department on more refinements to firefighter suits using new polymer fiber technology to keep the fire's heat away from the firefighters' bodies. It included a feature to circulate cooling liquids inside the suit.

Space age afoot. Space-related research has changed what we wear and how we exercise, from shoes to athletic wear. Nike first incorporated NASA shock absorbing material in its Nike Air running shoe in the early 1980s. New sportswear inspired by the cooling systems used in astronauts' spacesuits also is used to help athletes avoid overheating during strenuous exercise.

Homegrown space companies. The Clear Lake area has nurtured a number of space-related hometown companies, including NanoRacks, which maintains a permanent laboratory called NanoLabs aboard the ISS.

It is a beautiful and delightful sight to behold the body of the moon.

—Galileo Galilei

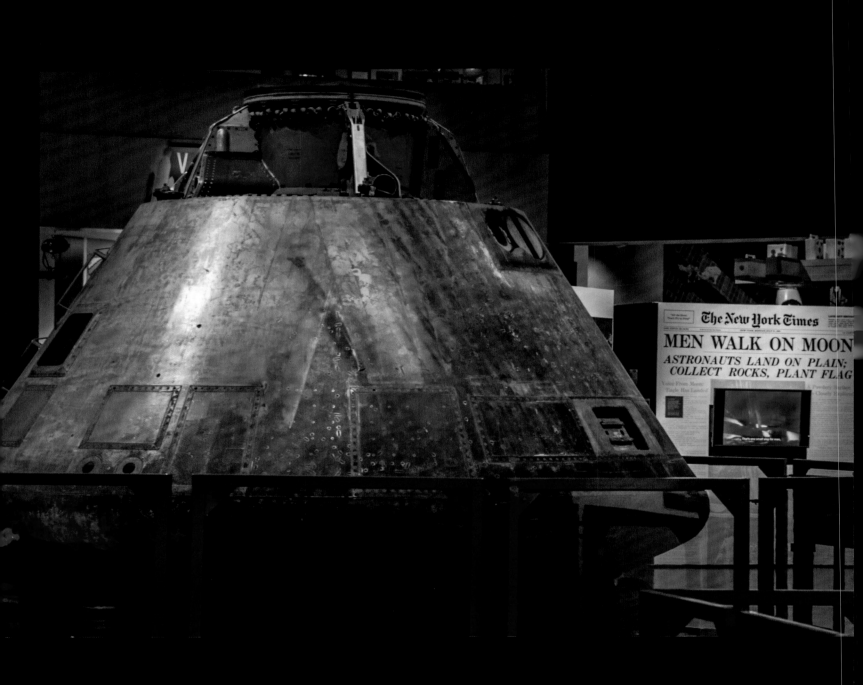

Destination moon. For the first time since 1969, the Apollo 11 command module came back to Houston in 2017–18 as part of the Smithsonian Institution's National Air and Space Museum traveling exhibition in advance of the fiftieth anniversary of the Apollo 11 lunar landing. The command module was first inspected at Johnson Space Center in 1969 following its return from the moon, and it then traveled on a fifty-state tour, covering more than 26,000 miles before entering the Smithsonian's permanent collection in 1971.

Chapter 4

NASA's Home on Clear Lake

Transforming from a Quiet, Rural Area to a Vibrant Community

The Clear Lake area has been a great location for NASA's manned space program and the thousands of engineers, scientists, researchers, technicians, administrators—and astronauts—who have called it home for more than fifty years.

—Astronaut Alan Bean

While other cities and regions develop and evolve relatively slowly over many decades, there is an obvious and clear line of demarcation for the Clear Lake area: September 19, 1961, the day that NASA formally announced that the area had been selected as the new home of what is today the Johnson Space Center (JSC). Previously, the unassuming tracts of rice fields, cattle ranches, and oil fields were indistinguishable from thousands of other acres along the Texas Gulf Coast and were often described as a collection of "sleepy fishing villages." The area's biggest claims to fame prior to 1961 were the illegal casinos that once operated in the 1950s near Kemah and El Lago's notoriety as one of the main hideouts for the famed pirate Jean Lafitte in the early 1800s.

Twenty miles away, the "big city" of Houston was a rowdy, fast-growing metropolitan area filled with "oil men," bankers, lawyers, and real estate developers bent on making their home-town the economic capital of the Southwest. For Houstonians prior to September 1961, the Clear Lake area was simply a place to go fishing and boating or to escape the pace of city life.

Prior to NASA's decision, the Clear Lake area had a population of 6,520. By the late 1960s, the area's population had skyrocketed to 45,000. Today, the collection of nine cities—Clear Lake City, Clear Lake Shores, El Lago, Kemah, League City, Nassau Bay, Seabrook, Taylor Lake Village, and Webster—clustered around the shores of Galveston Bay, Clear Creek, and Clear Lake—boast a population of more than 140,000.

In many ways, the area's natural and manmade attributes were the very reasons that it was selected for the new space laboratory. The area had everything that NASA was looking for: a mild climate that allowed work to continue year-round, barge and shipping access, nearby all-weather commercial jet service, an air base that could handle military jet aircraft, nearby universities, and—one of the biggest draws—one thousand acres of land that could be available immediately.

Houston's economy quickly benefited from the presence of the new space center, which spurred a significant increase in the number of manufacturing firms in the area. In 1962 alone, the then-Houston Chamber of Commerce reported that twenty-nine space-related companies had established offices and facilities in the area, including many of the largest space and technology-related companies at the time—Lockheed, Raytheon, Sperry-Rand, Honeywell, IBM, TRW, Texas Instruments, and General Electric, among others.

Through the decades, JSC's primary mission has remained serving as the home for human spaceflight and training astronauts from both the United States and its international partners. JSC is perhaps most famous for serving as mission control during the Gemini, Apollo, Skylab, Apollo-Soyuz, and Space Shuttle programs. Today, it is responsible for directing American activities aboard the International Space Station and leads NASA's human spaceflight-related scientific and medical research programs.

The following are among the one hundred buildings on the sprawling 1,620-acre JSC campus:

Christopher C. Kraft Jr. Mission Control Center. From the moment a human-occupied US spacecraft clears its launch tower until it lands back on Earth, it is in the hands of mission control. The mission control center houses several flight control rooms, from which flight controllers coordinate and monitor spaceflights. It is named after Christopher C. Kraft Jr. for his instrumental role in establishing NASA's mission control operations and serving as the agency's first flight director.

Apollo Mission Control Center. This national historic landmark has been restored to document how it looked and was operated during the historic Apollo moon missions.

Sonny Carter Training Facility and the Neutral Buoyancy Laboratory. Astronauts use the facility to train under simulated weightless conditions.

Lunar Sample Laboratory Facility. Most of the samples returned from the moon during the Apollo program are stored, analyzed, and studied in the lab's clean rooms.

Human Health and Performance Center. Located in one of the newest buildings on the JSC campus, the center focuses on enhancing crew health and performance and mitigating the risks associated with human spaceflight.

Space Vehicle Mockup Facility. The facility is used to train in and develop procedures for astronauts, engineers, and other mission support professionals to operate the space station. It is equipped with high fidelity, full-scale mockups of the space station's different habitable elements.

Virtual Reality Laboratory. The lab creates a computer-generated microgravity environment to prepare astronauts for spacewalks and use of the space station's robotic arm.

Ellington Airport. This airport is used by astronauts to maintain their flying proficiency by flying NASA's fleet of T-38 jets.

At its height, Johnson Space Center was home to 17,000 employees during the Apollo and Space Shuttle programs. Employment in the Clear Lake area has waxed and waned during the intervening years, but the JSC still counts about 3,000 civil servants and about another 7,500 contractor employees. Overall, JSC accounts for more than $1.4 billion annually in contractor

and civil servant salaries in Texas. Since the 1960s, Johnson Space Center has received more than $160 billion in federal appropriations, the majority of which has been spent in the Houston area and around the state of Texas.

Through the peaks and valleys of the US space program, the Clear Lake area still maintains much of its pre-1961 appeal. Sailing and boating on Clear Lake and Galveston Bay, for example, remain a favorite pastime and hobby for both residents and visitors. In fact, the area boasts one of the largest collection of boat slips in the country. The area still has a small-town feel to it, reinforced in part by family, friends, and coworkers, each with a shared connection to the space program.

The area's connections to the space program are everywhere, from street names like Saturn, Gemini, and NASA Parkway to parks, outdoor displays, and libraries filled with space-related books and artwork. Visitors can also dine under a bigger-than-life-sized astronaut hovering over a McDonald's or pick up the latest electronic gear while standing under an almost full-scale replica of the International Space Station inside a nearby Fry's Electronics store.

Space Center Houston

Since its opening in 1994 as the official visitor's center for Johnson Space Center, Space Center Houston has attracted more than twenty million visitors to see, touch, and explore NASA and space-related exhibits. Its success has made Space Center Houston the second biggest driver of the Clear Lake area economy, and it has become one of the largest tourist attractions in the Houston area and even in Texas as a whole. A 2016 study by the University of Houston–Clear Lake estimated that Space Center Houston had a $73 million annual economic impact on the greater Houston area as a result of drawing more than one million visitors yearly. More than 80 percent of those are reported to be from outside of the greater Houston area.

The center features more than four hundred space artifacts—including the world's largest collection of moon rocks and lunar samples available for public view—as well as permanent and traveling exhibits and attractions. The center is also Houston's first Smithsonian Affiliate museum. One of the biggest attractions at Space Center Houston is the space shuttle parked on top of the original Boeing 747 shuttle carrier aircraft in the center's Independence Plaza. The one-of-a-kind exhibit complex brings the Space Shuttle program legacy to life, teaching visitors how the shuttle flew across the country and showing them what the living and working areas for an astronaut were like. While at Space Center Houston, visitors also have an opportunity to go behind the scenes to see NASA Mission Control, International Space Station Mission Control, and astronaut training.

The Manned Space Flight Education Foundation, a nonprofit space museum with an extensive science education program, operates Space Center Houston, which draws more than 100,000 teachers and students each year from around the world.

Home of the Astronauts

While fewer in number and with less celebrity status than in the 1960s, most of the current astronaut corps still call the Clear Lake area home and are embraced as neighbors throughout the community. El Lago claims to be the "home of the astronauts" and over the years has counted more than forty astronauts as residents, including Neil Armstrong, Fred Haise, Jim Lovell, Story Musgrave, Thomas Stafford, Ed White, Peggy Whitson, and John Young.

In Taylor Lake Village, the Timber Cove subdivision was established in 1958, the same year that NASA was created. Although it grew slowly at first, the subdivision took off after NASA announced plans to build the Manned Spacecraft Center on property less than three miles to the east in the fall of 1961. Over the years, Timber Cove has been home to many astronauts, including four of the original Mercury 7 astronauts: Scott Carpenter, John Glenn, Gus Grissom, and Wally Schirra. Today, Timber Cove still proudly proclaims itself as the "Home of Friends, Families and Astronauts" on signage designed to look like a NASA mission patch that features stars representing the original seven Mercury 7 astronauts.

Celebrating space

The Clear Lake area has celebrated its ties to the US space program with a variety of special events through the years. The Lunar Rendezvous Festival, for example, began to preserve the history and accomplishments in the space sciences made in the area. The first festival, in June of 1966, included a salute to the space program's historic 1965 rendezvous of Gemini VI and Gemini VII. Festival proceeds go toward maintaining the Bay Area Museum as well as funding college scholarships for local students.

Sailing hot spot. The Clear Lake area is a favorite destination for sailing and other water sports. The area boasts one of the largest collection of boat slips in the country.

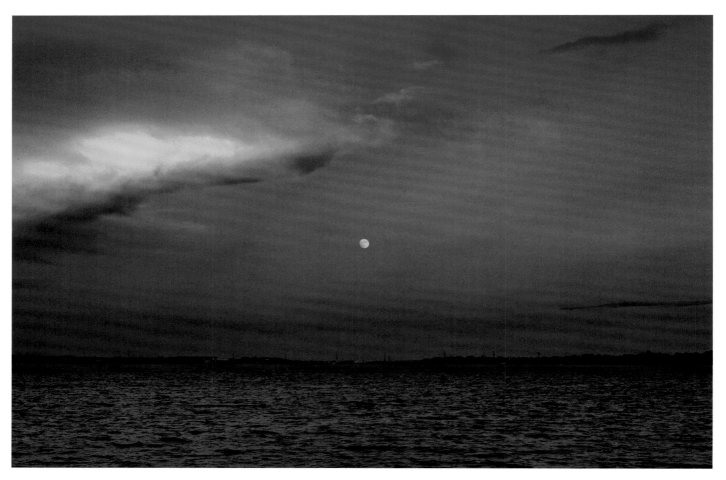

On the lake. The dock by the Clear Lake Hilton as well as Clear Lake Park on NASA Road 1 are great spots to watch the moon rise over Clear Lake.

A supermoon! By definition, a supermoon occurs when the moon is full and at the closest point to Earth, causing the moon to look somewhat bigger and brighter in the sky than usual. While a supermoon looks 15 percent bigger and 16 percent brighter than a typical full moon, it is difficult for the average person to see much of a difference. In 2017, there was a supermoon in three consecutive months: October, November, and December. The November 2017 supermoon was the brightest since 1948. The next full moon that will look that big will not occur until November 25, 2034.

Beacon in the night. The Kemah Lighthouse has become a landmark for the area along State Highway 146 just south of the Kemah bridge. Located near the Galveston Bay waterfront, the Kemah Lighthouse District features a variety of shops and restaurants.

Moonlight on the lake. Sitting on the edge of a peninsula on Clear Lake, the lighthouse at South Shore Harbour Resort serves as a beacon—at least figuratively—for boats docking at one of the largest marinas in the Clear Lake area.

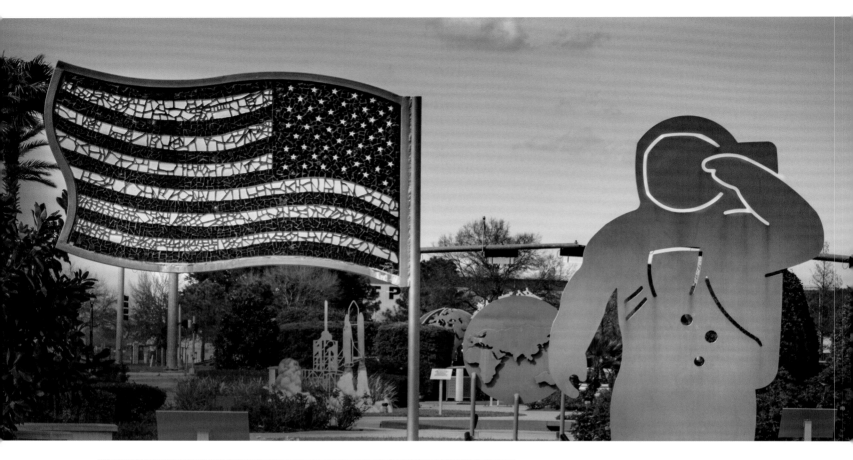

Space Walk Plaza. Sculptor Eric Ober designed a space-themed sculpture garden in the center of Nassau Bay Town Square across from Johnson Space Center. The sculpture garden was created by developer Griffin Partners as a tribute to the space agency and its impact on the Bay Area Houston community. The plaza features several steel monuments honoring key milestones in the human space program.

Home of human spaceflight. Building 1 at Johnson Space Center includes the offices of the center director and other senior management staff.

Home on the range. Dozens of deer can be found grazing on the grounds of Johnson Space Center. One popular spot for the deer is the astronaut memorial grove near the campus entrance.

ISS Mission Control. All US International Space Station operations currently are managed from the latest mission control room at Johnson Space Center, which has all controllers and engineering specialists at the same level. Previous versions featured a tiered floor layout. An observation and VIP visitors' gallery is located behind the control room behind glass walls.

Failure is not an option. Former NASA flight director Gene Kranz led the effort to restore and refurbish Johnson Space Center's mission control room to its historic Apollo-era configuration. The room was used during all of the Apollo missions.

The original mission control. Mission Operations and Control Room 2, last used in 1992 as the flight control room during the shuttle program, can still be seen by visitors on tours led by Space Center Houston.

Operational control for the International Space Station. The Christopher C. Kraft Mission Control Center functions around the clock as the operational control center for all activities aboard the International Space Station. It is named after Christopher C. Kraft Jr. for his instrumental role in establishing NASA's mission control operations and serving as the agency's first flight director.

Historic mission control in Houston. Johnson Space Center's mission control center was designated a national historic landmark in 1985 for its role as the flight control room for Apollo 11. Together with several support wings, it is now listed in the national register of historic places as the Apollo Mission Control Center.

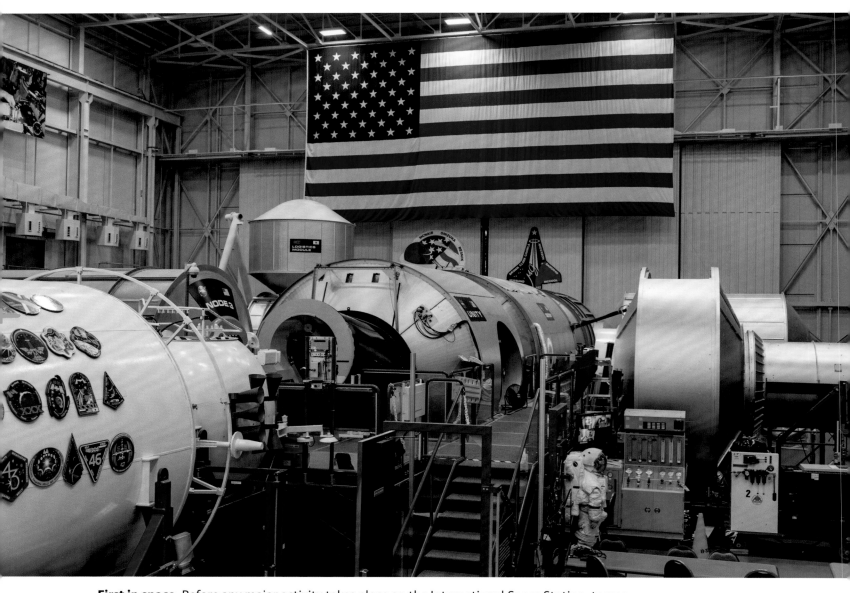

First in space. Before any major activity takes place on the International Space Station, teams on the ground at Johnson Space Center conduct simulations using high-fidelity mockups.

The future of deep space travel. As the lead NASA center for human spaceflight, Johnson Space Center is heavily involved in the design of the Orion spacecraft. When launched as Exploration Mission-1 (EM-1) on top of NASA's new Space Launch System rocket, the capsule's first uncrewed flight test will fly farther than any spacecraft built for humans has ever flown. Returning from 280,000 miles from Earth, it will also come home faster and hotter than ever before.

Supersonic trainer. Based at Ellington Airport and capable of reaching supersonic speeds (Mach 1.3: 858 mph), the T-38 is NASA's official training jet for astronauts. Likewise, more than 60,000 US Air Force pilots have trained in the two-seat, twinjets since they entered service in 1961 as the world's first supersonic trainers.

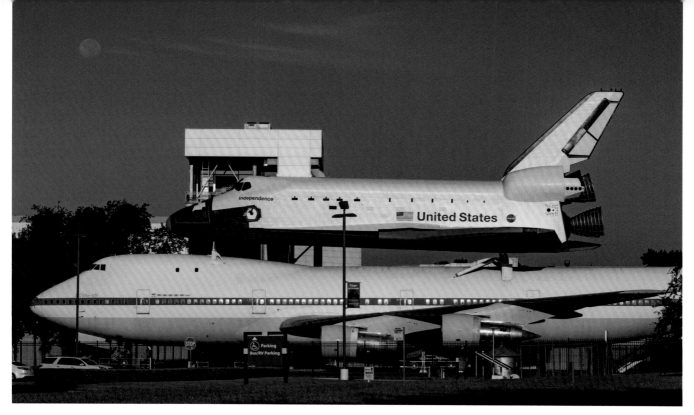

Space shuttle: designed and developed in Houston. A modified Boeing 747 jetliner was first used as the shuttle carrier during tests in the late 1970s to prove that the shuttle orbiters could land safely back on Earth. It then ferried the shuttles piggyback across the United States, returning them to Florida from their landing sites and delivering them for servicing between missions. Ellen Ochoa, then-director of Johnson Space Center and a space shuttle astronaut who flew four missions, noted during the opening of Independence Plaza that "Johnson Space Center designed and developed the space shuttle—including the concept of the shuttle carrier aircraft— and we are the center that trained for and carried out all 135 shuttle missions."

Attach orbiter here. Note: Black side down. Who says rocket scientists don't have a sense of humor? Mounted on the bottom of the shuttle *Independence* at Space Center Houston, a small plaque provides clear assembly directions for the crew that attached the shuttle to its carrier.

Moon rocks. The lunar vault in Starship Gallery at Space Center Houston is a certified clean room modeled after the Lunar Sample Laboratory Facility at Johnson Space Center. Visitors here can view a cross-section of a lunar sample under a microscope and see the largest exhibit of moon rocks on public display in the world.

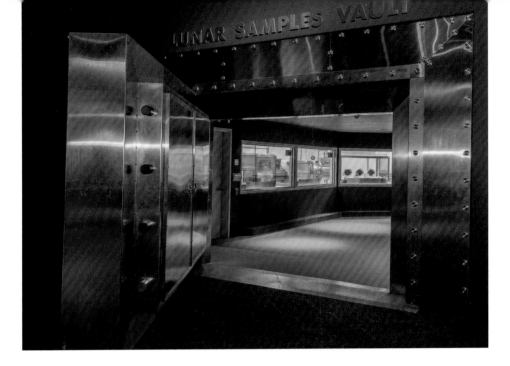

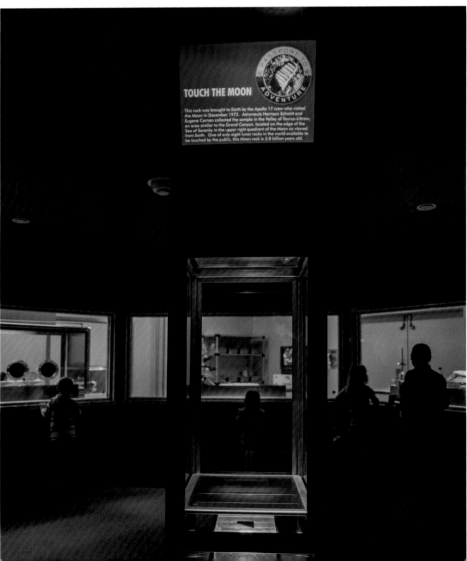

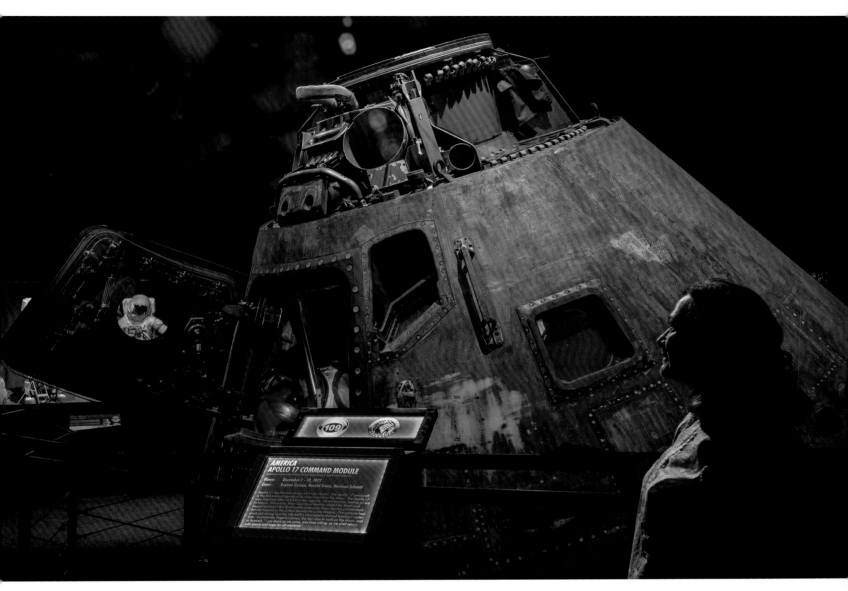

Final moon mission. In addition to safely returning its crew, the command module for Apollo 17 (named America) brought back 243 pounds of lunar samples in the last Apollo mission to the moon in December 1972. It is now on display at Space Center Houston.

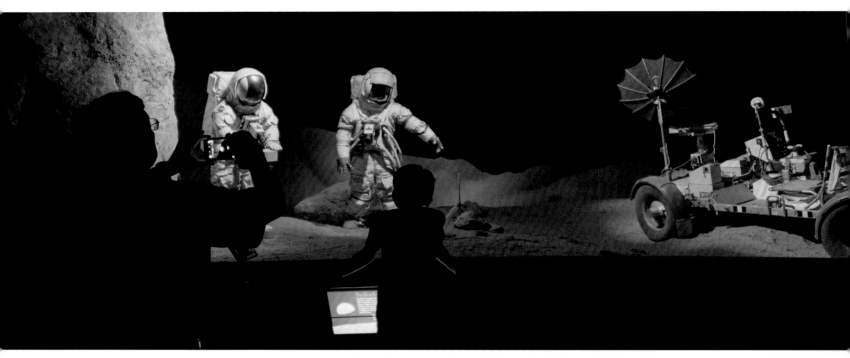

Moon walks and rover rides. Rovers were taken to the moon's surface (and left there) on the last three Apollo missions. Astronauts Dave Scott, Jim Irwin, John Young, Charles Duke, Gene Cernan, and Harrison Schmitt all practiced on the lunar rover trainer displayed at Space Center Houston. The electric-powered rover could travel at almost ten mph and had a range of about fifty-five miles.

Out on a LM. Before there was a lunar module, there was first a lunar module test article (LM TA8). As part of the Apollo program, the lunar module was designed to transport astronauts to and from the lunar surface as well as serve as a base camp to support life on the moon. But first, NASA wanted to put a test version through its paces on Earth to ensure the safety and success for every astronaut. The LM TA8 underwent a battery of tests under simulated mission conditions for more than 160 hours.

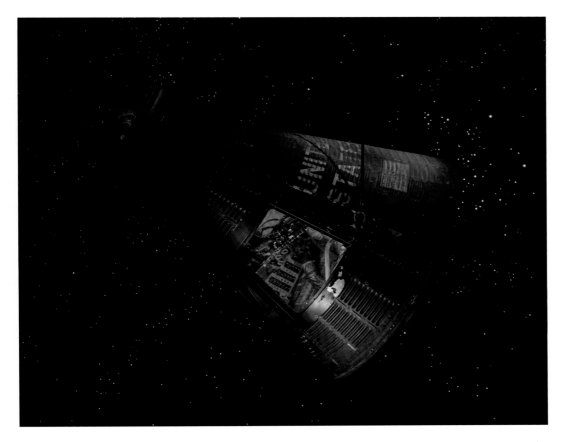

Piloted by faith. Astronaut Gordon Cooper said he selected the name Faith 7 for his spacecraft to express his faith in his fellow workers, in the spaceflight hardware, in himself, and in God. Faith 7 was the final Mercury spacecraft to go into orbit on May 15–16, 1963.

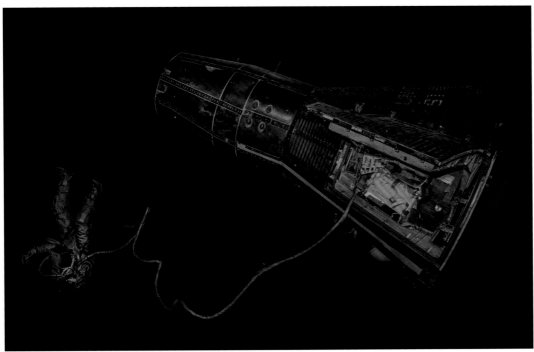

Eight days a week. Gemini V set a record for space flights (at the time) in August 1965 when it circled the Earth 120 times in just under eight days. In the process, it also validated that NASA's spacecraft designs could withstand the future challenges expected on an eight-day journey to the moon and back.

Apollo Honor Roll. As part of Space Center Houston, visitors can tour Rocket Park at Johnson Space Center and explore a full-size Saturn V, the same type of rocket that was used to launch all of the Apollo capsules. Visitors also can learn about each of the Apollo missions.

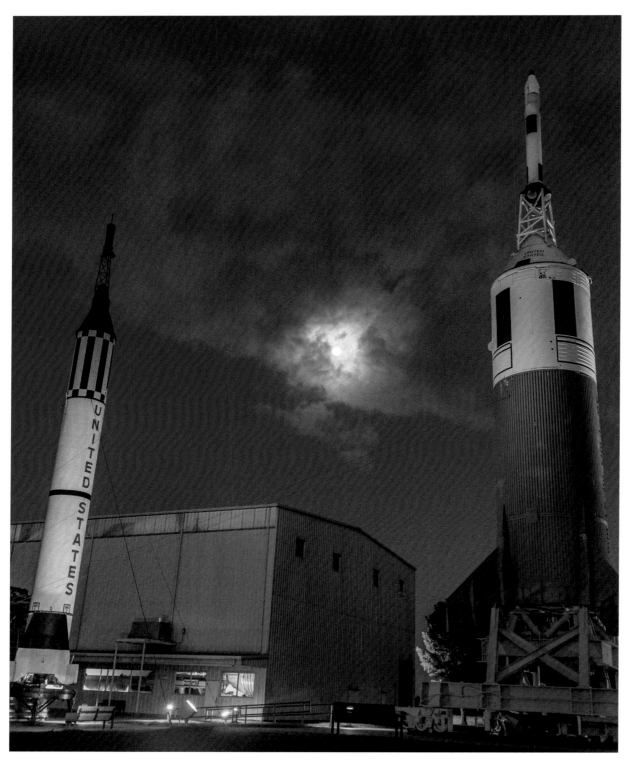

Rocket Park. Visitors to Space Center Houston can get up close with several NASA rockets on display at Rocket Park as part of the tram tour.

Festival of flight. For many years Johnson Space Center hosted the Ballunar Liftoff Festival as part of an open house for the community on its campus. At the festival's peak, more than fifty hot air balloons of all shapes and sizes lifted off near Rocket Park. In many ways, today's space program traces its roots to the hot air balloon, the first successful human-carrying flight technology. The first untethered human hot air balloon took flight on November 21, 1783, in Paris, France.

Space celebrations and libations. Reflecting its support for the space program while also finding a reason to celebrate year-round, the Spec's store in the Clear Lake area changes out accessories on the store's astronaut spacesuit to reflect different holiday themes throughout the year. Spec's isn't alone. Spacesuits and space-related images grace the aisles and walls of many stores in the area.

Where astronauts go for real Italian food.
Francesco (Frankie) Camera and his brother
Giuseppe have been attracting NASA engineers
and astronauts to their small Italian restaurant,
Frenchie's, since they opened it in 1979. As a sign
of the restaurant's appeal, its walls are lined
with signed astronaut photographs and other
memorabilia donated by admiring fans.

Shopping under the International Space Station. The Fry's Electronics store chain allows each of its locations to decorate its store in a way that best represents and reflects the community it serves. For the store near NASA, the choice was obvious: a seven-eighths size replica of the International Space Station.

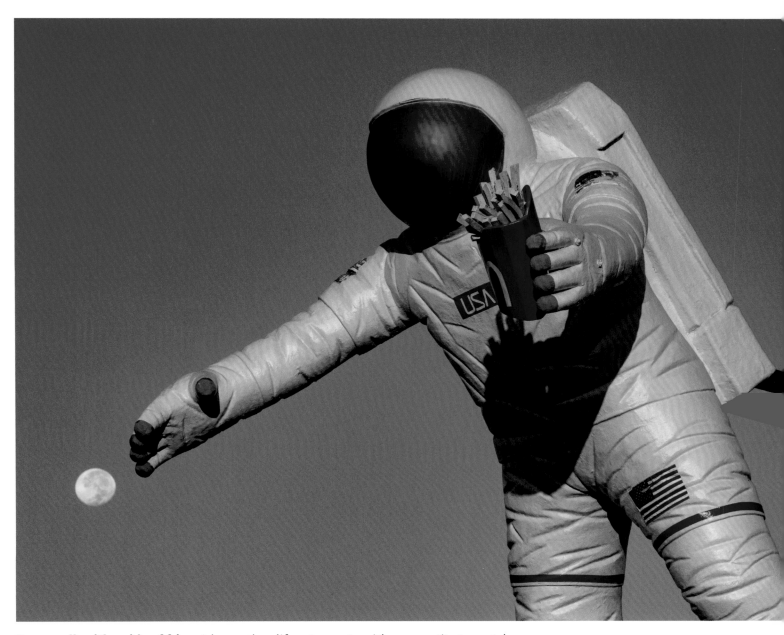

Spacewalk with a side of fries. A larger than life astronaut—with an appetite to match—can be found floating above the McDonald's on NASA Road 1 near Johnson Space Center.

Stargazers: The next generation. When the space program was just getting underway at Johnson Space Center, nearby La Porte High School became one of only two schools in Texas with its own planetarium. Fifty years later the school district approved a bond proposal to replace the planetarium with a state-of-the-art facility as part of its science, technology, engineering, and math programs.

Fascinated by the heavens. The Lunar and Planetary Institute, with assistance from Johnson Space Center Astronomical Society, offers SkyFest at the Institute several times each year to give explorers of all ages an opportunity to look through telescopes (weather permitting). During full moon viewing events, specially mounted binoculars can be used to see details on the lunar surface.

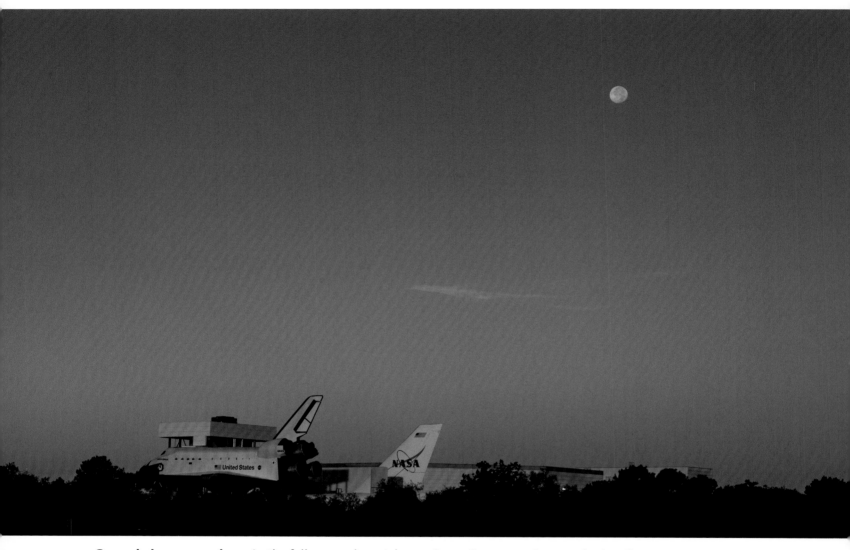

Grounded museum piece. As the full moon above Johnson Space Center continues to beckon future space explorers, a mockup of the space shuttle and the original shuttle carrier aircraft rest on display as tourist attractions and modern museum pieces on the grounds of Space Center Houston.

Everyone is a moon and has a dark side which he never shows to anybody.

—Mark Twain

Earthrise: Our world from a different perspective. While earlier human and nonhuman missions had photographed Earth from space, Apollo 8 was the first time that a human was able to photograph an "earthrise." Photo by NASA

Heavenly Inspiration

Looking above for Knowledge
and Meaning

In the beginning God created the heaven and the earth. And the earth was without form, and void; and darkness was upon the face of the deep.... And God said, Let there be light: and there was light. And God saw the light, that it was good: and God divided the light from the darkness. And God called the light Day, and the darkness he called Night.

—Genesis 1:1–5 (King James Version)

The heavens have mesmerized and inspired humanity since the beginning of time. Alone in the darkness we have tried to make sense of the world around us. In the process, we have been inspired to create the following:

Science and mathematics to try to instill order and logic

Through the millennia, humanity has turned to the heavens to create a sense of time and seasons. The result was the creation of calendars to help explain the unfathomable while bringing order and some level of predictability to life during the course of a year.

Religions to try to bring meaning and purpose to life

Calendars—whether they are solar- or lunar-based—can be found at the heart of many religions. Traditional lunar and lunisolar calendars (whose lunar months are brought into alignment with the solar year) have been used throughout history to determine religious festivals and national holidays. These include Ramadan (Islamic calendar); the Chinese, Japanese, Korean, and Vietnamese New Year; and Diwali (Hindu calendars).

Art to try to capture and reflect what our eyes see all around us

The heavens—the moon, sun, and stars—have inspired writers, poets, musicians, and artists of all sorts across time. The results can be found from primitive etchings and drawings to engineering marvels like the pyramids and Stonehenge or from folk dances and songs to classical music and even in the lyrics of more current songs.

Music

The moon has been the inspiration for dozens of songs, from classical music like Beethoven's "Moonlight Sonata" and Debussy's "Clair de Lune" to songs from the '50s like "Moon River" and "Fly me to the Moon" to more modern pop favorites like "Bad Moon on the Rise," "Dancing in the Moonlight," "Moondance" and "Harvest Moon." NASA maintains a database of music and songs with "moon" in their title. The site also lists songs about Project Apollo and "colorful"

moon songs (e.g., "Blue Moon"). A section on geographical moon songs highlights songs from several cities and states, including three featuring Texas in the title: "Texas Moon," "Under a Texas Moon," and "Roll on Texas Moon." You can access the database here: https://moon.nasa.gov/moonsongs.cfm.

NASA has even used music to wake up its crews in space since the early days of the space program. The first wakeup call was "Hello Dolly" during Gemini 6 in 1965. Here are a few more wakeup songs:

- Over the years, several crews have awakened on their final day in space to Dean Martin's popular song "Going Back to Houston."

- The "Texas Aggie War Hymn" was played to wake up the lunar crew of Apollo 17 on December 13, 1972, in honor of flight director's Gerry Griffin's alma mater, Texas A&M University.

- In 2005, Paul McCartney performed a special live musical wakeup call during the first-ever concert linkup with the International Space Station. McCartney sang two songs, "Good Day Sunshine" and "English Team," for astronaut Bill McArthur and Russian cosmonaut Valery Tokarev.

The Houston Symphony has performed a number of works with space themes, ranging from John Williams' scores for the *Star Wars* movies to Richard Strauss' *Also sprach Zarathustra* (*Thus Spake Zarathustra*), used by filmmaker Stanley Kubrick in *2001: A Space Odyssey*. On July 20, 2018, the forty-ninth anniversary of the Apollo 11 lunar landing, the Houston Symphony performed the Oscar-nominated score for the movie *Apollo 13* while the movie was projected on a large screen at Jones Hall. In 2015, the Houston Grand Opera hosted the world premiere of *O Columbia*, a three-act chamber opera that it commissioned to honor and celebrate the American spirit of exploration. The opera is based in part on interviews with NASA employees about the Space Shuttle Columbia tragedy in 2003.

Film

CineSpace, a short film competition sponsored by NASA and Houston Cinema Arts Society, offers filmmakers around the world a chance to share their works inspired by and using actual NASA imagery. Submissions must contain at least ten percent NASA video imagery. Winners are announced and screened, along with all finalists, at the annual Houston Cinema Arts Festival each November.

On the big screen, Houston and its role in the US space program have also figured prominently in dozens of movies. Some are based on real space adventures such as *For All Mankind* and *Apollo 13*. Others were simply filmed in Houston or Johnson Space Center, including

Futureworld (1976), *Logan's Run* (1976), *Terms of Endearment* (1982), *I Come in Peace* (1990), *Independence Day* (1996), *Armageddon* (1998), *Space Cowboys* (2000), *Transformers: Dark of the Moon* (2011), and *The Martian* (2015).

Space art

NASA has supported the arts since 1962 when NASA administrator James Webb established a program and began commissioning artists to document the history of space flight. According to NASA, "important events can be interpreted by artists to give a unique insight into significant aspects of our history-making advances into space. An artistic record of this nation's program of space exploration will have great value for future generations and may make a significant contribution to the history of American art." Early work ranged in style from paintings by Norman Rockwell at Johnson Space Center to the avant-garde artwork of Texas native Robert Rauschenberg. Over the years, NASA expanded the collections to include photography, music, and other art forms.

Likewise, the Museum of Fine Arts, Houston, maintains a small collection of photographs taken by NASA over the years. Johnson Space Center has also sponsored several arts programs in the Houston area, including space-inspired quilts and the Space Suit Art Project with the University of Texas MD Anderson Cancer Center, among other programs.

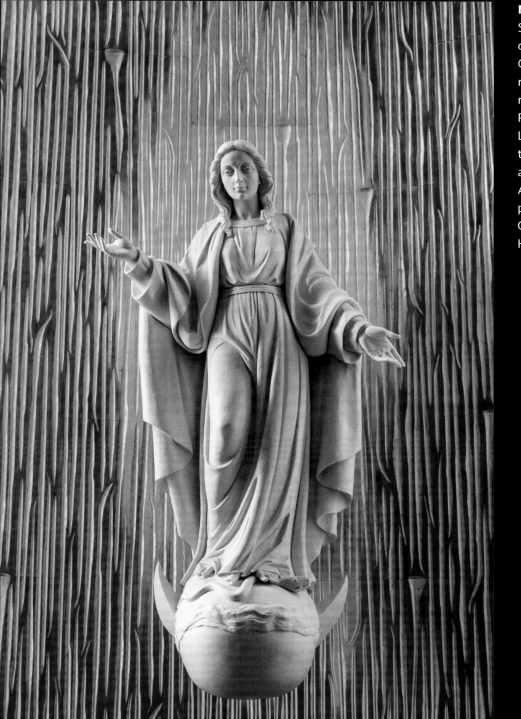

Nuestra Señora de Guadalupe.
Standing on a globe and crescent moon, Our Lady of Guadalupe has been a revered religious symbol of the Catholic religion in Mexico for centuries. Paintings and statues of Our Lady of Guadalupe can be found throughout Houston's Catholic and Hispanic communities. A life-size statue is featured prominently in the Sacred Heart Co-Cathedral in downtown Houston.

Celebrating Easter. The date Christians celebrate the resurrection of Jesus on Easter Sunday is determined on a lunisolar calendar similar to the Hebrew calendar. The First Council of Nicaea in 325 AD pushed the early church to establish worldwide uniformity for the date. Through tradition that has come to be the first Sunday after the full moon that occurs on or soonest after the spring equinox on March 21.

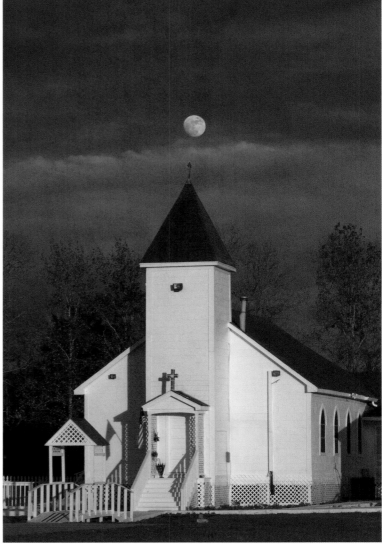

Moonrise over Barker church. A simple wood frame church in far west Houston gives silent witness to the moonrise. The church is on the location of the former Marks LH7 ranch, a once-bustling cattle ranch owned by one of the founders of the Salt Grass Trail Ride that each year opens the Houston Livestock Show and Rodeo.

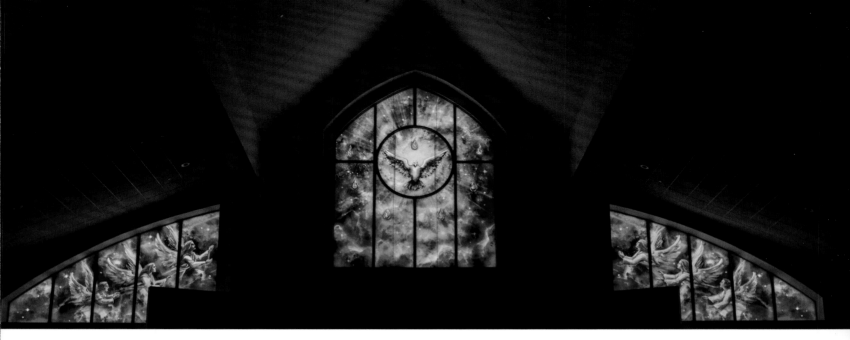

Inspiring majesty of the heavens. The stained glass windows of St. Paul the Apostle Catholic Church in Nassau Bay are based on images from the Hubble telescope of the Orion Nebula and Omega-Swan Nebula. The artwork was created by copying actual photos from NASA onto large panes of glass.

Spiritual connections. During the early days of the space program, Webster Presbyterian Church was known as the church of the astronauts, where John Glenn, Buzz Aldrin, Jerry Carr, Charles Bassett, and Roger Chaffee worshipped. As a member of the Apollo 11 lunar mission, Aldrin took communion using a chalice and elements given to him by the church. The church continues to honor the historic service annually on the Sunday nearest the anniversary of the first moon landing. The church's windows were inspired by images from the Hubble telescope, and one contains fragments of the Allende meteorite that fell in Mexico in February 1969.

Illuminating faith and astronomy. A crescent moon shape can often be found on top of mosques and has become recognized as a symbol for the Islamic religion, although some historians debate the origin and association of the crescent moon with the religion. Traditionally, the first day of each month in the Islamic calendar is the day (beginning at sunset) of the first sighting of the hilal (crescent moon) shortly after sunset. Determining the most likely day that the hilal would be observed was a motivation for early Muslim interest in astronomy.

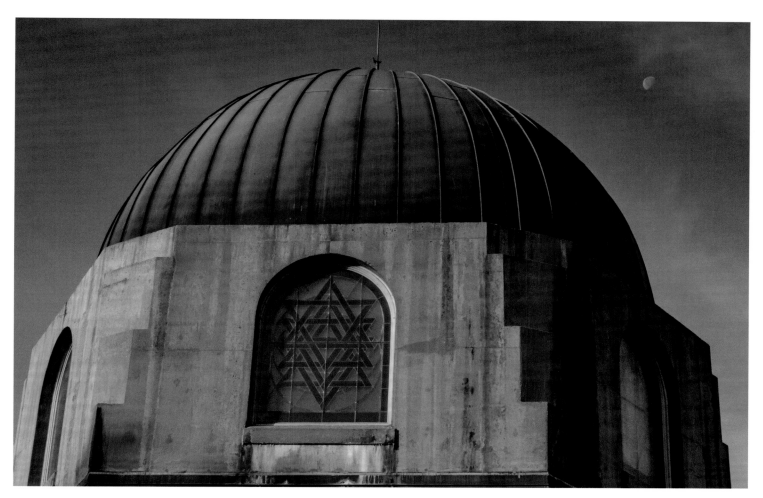

Passover. The Jewish holy day of Passover typically begins on the night of the first full moon after the spring equinox. Passover commemorates the story of Exodus in the Hebrew Bible in which the Israelites were freed from slavery in Egypt.

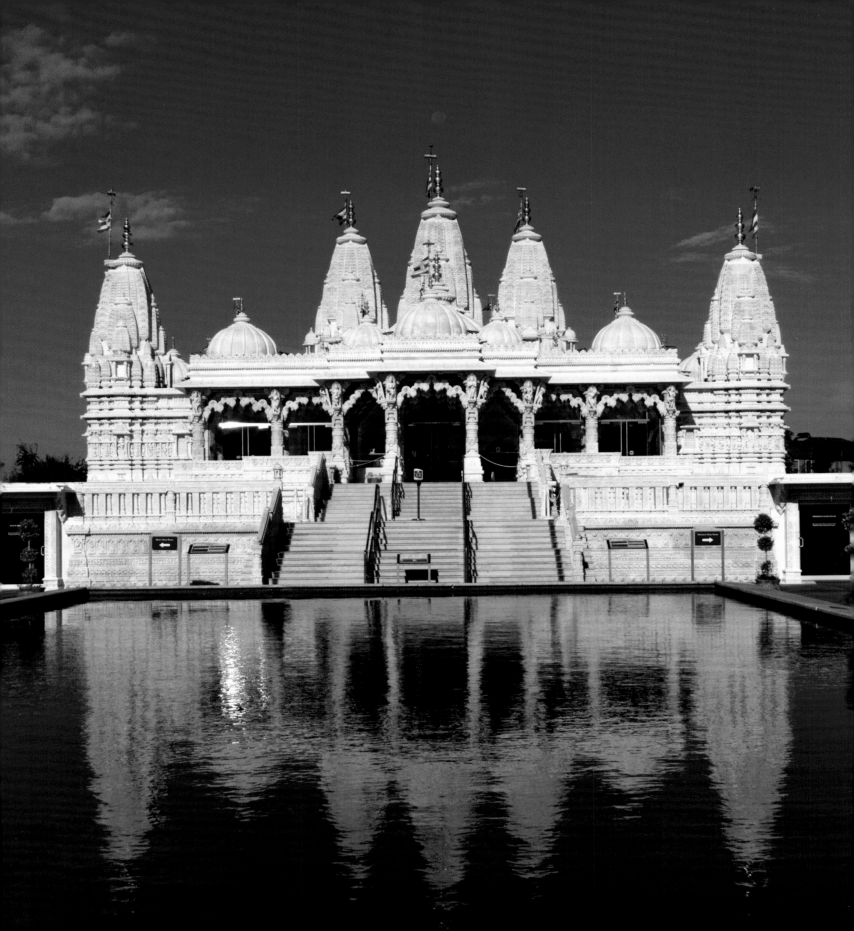

Texas-sized Hindu temple. The twenty-two-acre BAPS Shri Swaminarayan Mandir, located in Stafford, southwest of Houston, is a traditional Hindu temple and the largest of its kind in Texas. In the Hindu faith, the lord Shiva wears a crescent moon in his hair to signify his control over time and the fact that he is the beginning and the end of all things in the universe.

Born on a full moon. The moon has a special significance in Buddhism because many of the most important events connected with the life of the lord Buddha are believed to have taken place on full moon days, including his birth, enlightenment, and his passing away into Nirvana. In addition, the phases of the moon are said to represent the cycle of birth, death, and rebirth, a core tenet of Buddhism.

Mayan inspired. The soaring granite Mayan flat-topped pyramid on top of the fifty-three-story Heritage Plaza in downtown Houston is said to have been inspired by the architect's visit to Mexico's Yucatán peninsula. The ancient Mayans were keen astronomers, and during the Classic Maya period (200–1000 AD), the Mayans developed some of the most accurate pre-telescope astronomy in the world. In fact, their calculation of the length of the tropical solar year is said to have been more accurate than that of the Spanish when they first arrived. The Mayan priests/astronomers were known as the *ilhuica tlamatilizmatini*, or "wise man who studies heaven".

Timeless interest in astronomy. In ancient Egypt, astronomy played an important role in setting the dates of religious festivals and determining the hours of the night. At Galveston's Moody Gardens, three glass-cased pyramids house tropical rainforests, aquarium, and scientific exhibits.

Shine on harvest moon. The name harvest moon is the traditional term for the full moon occurring closest to the autumnal equinox (September 22 or 23). With its southern location, Houston's harvest moon does not directly correspond to the harvest times for many local crops, including cotton, which is often harvested as late as October.

Moonstruck. Take one part moss-covered trees and add in a full moon peeking through the branches on a dark night and you have everything you need to set the scene from a murder mystery, horror movie, or just a bad dream. Because of alleged connections between the moon and unusual behavior in the middle ages, the afflicted were called lunatics, or, literally, moonstruck.

Spooked by aerodynamics. With their wildly flailing bodies, air dancers are popular ways to attract traffic to stores selling Halloween costumes and decorations. Also known as sky dancers, the inflatable devices owe their attention-getting performance to the same basic aerodynamic forces that have been used for thousands of years in sailboats and windmills.

East meets West at lantern festival. While Chinese lantern festivals have been held for more than two thousand years, the Magical Lights Festival held in Houston mixes tradition with technology and modern themes. Although no one knows the origin, lantern festivals are historically tied to Chinese and Asian new year celebrations. It is believed the festival was meant to celebrate the declining darkness of winter and the ability to move through the dark with human-generated light.

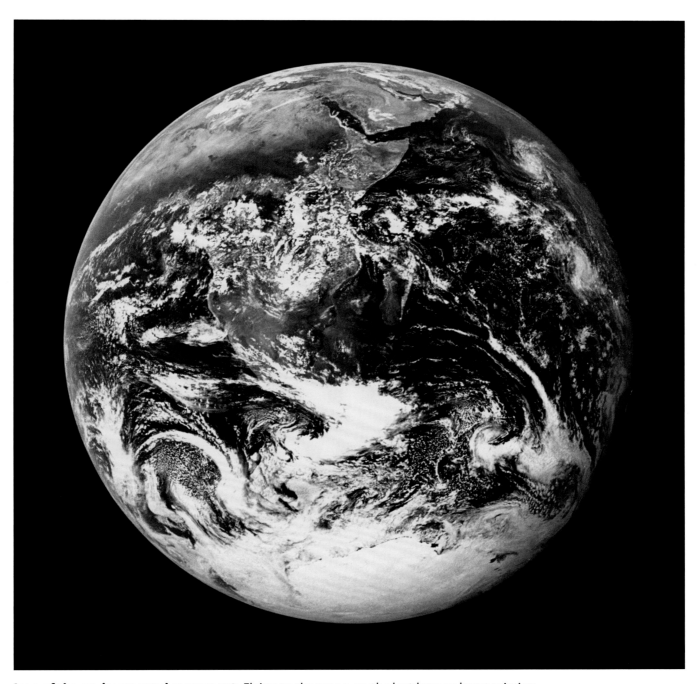

Icon of the environmental movement. Flying to the moon on the last human lunar mission, the crew of Apollo 17 captured one of the most reproduced images of the Earth. The "Blue Marble" photograph of Earth was made on December 7, 1972, at a distance of about 28,000 miles. The image's depiction of Earth's frailty, vulnerability, and isolation amid the vast expanse of space became a symbol of the environmental movement at the time. Photo courtesy of NASA

"Our World at My Fingertips." As the fourth man to walk on the moon, Alan Bean's experience on Apollo 12 and later on Skylab 3 inspired him to capture the wonder and excitement of space travel in his art work. Through dozens of paintings and other works of art, Bean has shared his unique perspective gained from walking on the moon and seeing sights no other artist's eye, past or present, has ever viewed firsthand. "I believe that one hundred, two hundred, three hundred years from now all these paintings will be around, because they're the first paintings of humans doing things off this Earth." Painting by Alan Bean

"Our Moon in My Hands." Inspired by astronaut Alan Bean's artwork, today's digital tools were used to combine images of the moon, NASA space gloves, and beach sand to pay homage to Bean's "Our World at My Fingertips."

Hope for child cancer patients. Inspired by its successful arts in medicine program, the University of Texas MD Anderson Cancer Center teamed up with Johnson Space Center and spacesuit maker ILC Dover to launch the Space Suit Art Project. More than 530 child cancer patients, families, and staff members painted original artwork that was then used to create full-sized suits for the Space Suit Art Project. Several of the special spacesuits were flown on the International Space Station.

Moonlight sonata. The Piano Sonata No. 14 in C-sharp minor "Quasi una fantasia," Op. 27, No. 2, popularly known as the "Moonlight Sonata," was created by Ludwig van Beethoven. The name "Moonlight Sonata" is attributed to German music critic and poet Ludwig Rellstab, who likened the effect of the first movement to that of moonlight shining upon Lake Lucerne. The floating piano is an aerial landmark on the Southwest Freeway and Kirby Drive, home of the Fort Bend Music Center.

Time and Relative Dimension in Space. At the height of the US space program in the 1960s, the British science fiction television show Doctor Who—with its iconic time-travel machine, the TARDIS, disguised as a British Police Call Box—soared to popularity. It remains popular among sci-fi fans around the world, including in Houston where visitors can step into a TARDIS replica at GeekLife in the Heights area.

To boldly go. From its initial run on television in the late 1960s, the Star Trek television show and subsequent movies have captured the imagination of millions around the world. One of the few original set pieces to survive from the 1960s, the Star Trek shuttlecraft *Galileo* can now be found at Space Center Houston. Despite its groundbreaking success and the prescience of its creator Gene Rodenberry, the television series ended its three-year run on June 3, 1969, just a few weeks before the Apollo 11 lunar landing.

And the Emmy goes to . . . Orion: Trial by Fire. The information technology and multimedia services team at Johnson Space Center won a highly coveted Lone Star Emmy Award from the Lone Star chapter of the National Academy of Television Arts and Sciences for their video about the exploration vehicle that will one day carry astronauts to Mars.

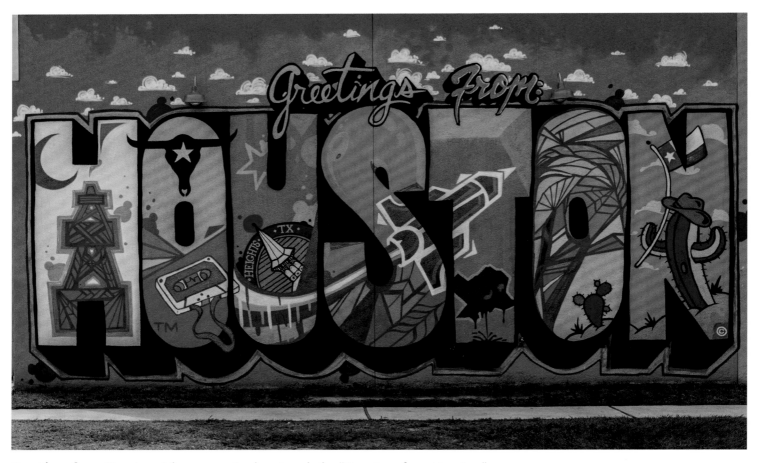

Greetings from Houston. Like an oversized postcard, the "Greetings from Houston" mural on a gelato shop in the Heights neighborhood highlights some of the many scenes (both real and imagined) that visitors might associate with a trip to Houston.

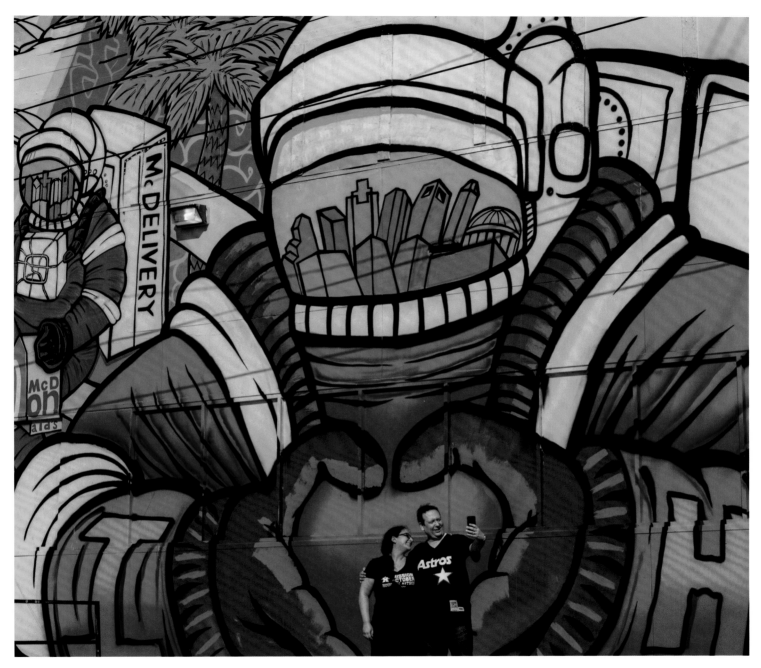

A perfect selfie spot in Houston. Astronauts have joined cowboys and oil derricks to become modern iconic images for the city. HoustonFirst has sponsored and encouraged dozens of artists to transform the cityscape from concrete to color, including several walls at Graffiti Park near 2011 Leeland in downtown Houston.

Metered parking in "Downtown Mars." Artist Sebastien Boileau says creating the "Downtown Mars" mural that wraps a three-story building at 1301 Leeland required one hundred gallons of paint and three hundred cans of spray paint.

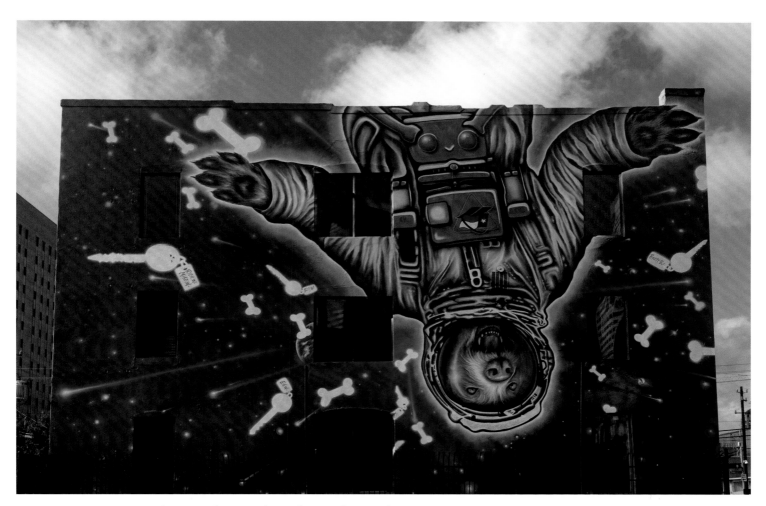

Dog-gone astronaut. Boileau says his mural was designed to pay homage to Houston with a colorful and whimsical space twist.

Other worldly wall.
Houston-based artist Gelson Danilo Lemus (whose tag is w3r30n3) blended a variety of styles and images—from sci-fi to graphics arts, even a Houston Astros baseball cap—to create an out-of-this-world mural on North Main and Gargan Street.

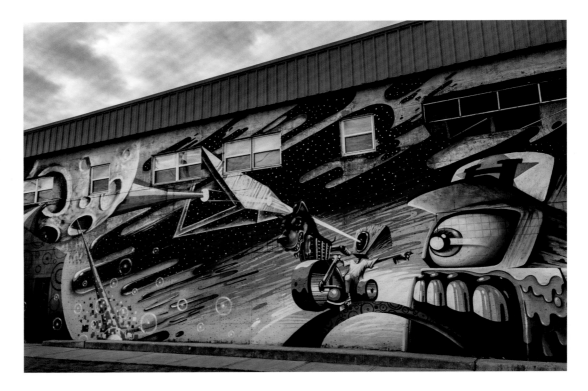

Pies to fly for. Flying Saucer Pie Company on West Crosstimbers in Houston has been selling pies since 1967. The bakery has attracted thousands of loyal customers for their "out of this world" pies. During the holiday season, it sells more than twenty thousand pies a month.

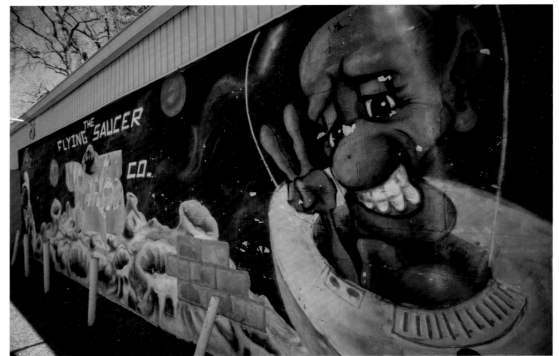

Art imitates life. In the 1960s, many retail department stores featured "picture windows" displaying the latest fashions or holiday gifts. In 2017, the St. Germain Lofts in downtown Houston elected to use its street-level windows to create a lunar landing scene, complete with an image of a lunar landing module, an unfurled American flag, and an earthrise on the horizon.

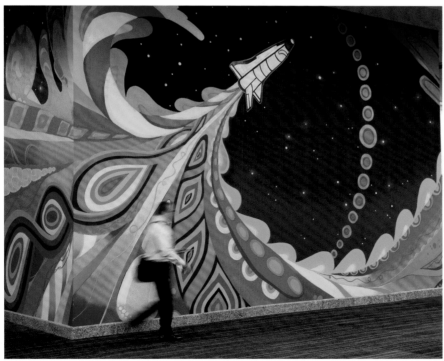

Lifting Off, Living Houston and Beyond. One of Houston's leading graphic/graffiti artists, Mario E. Figueroa Jr., who also goes by GONZO247, says he designed "Lifting Off, Living Houston and Beyond" as a tribute to the city's connection to the US space program. The mural is in a prominent spot in the George R. Brown Convention Center.

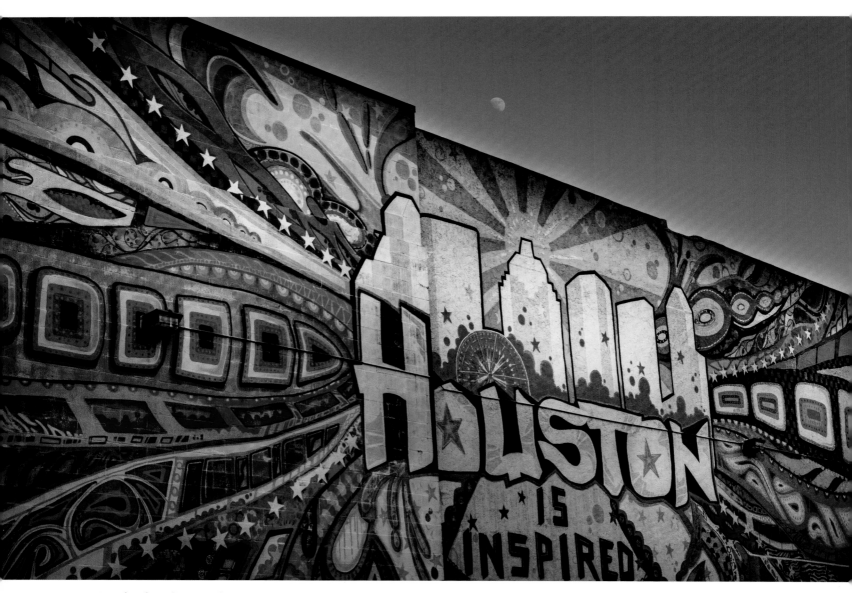

Inspirational artwork. To promote its "Houston Is" campaign, the Greater Houston Convention and Visitors Bureau commissioned GONZO247 to decorate a wall on the side of the Treebeards restaurant in downtown Houston's Market Square area. His creative vision: "Houston Is Inspired."

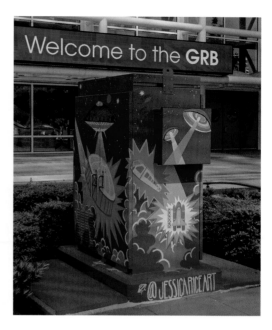

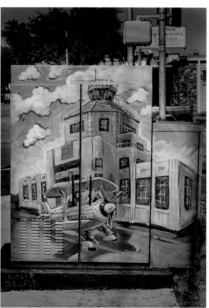

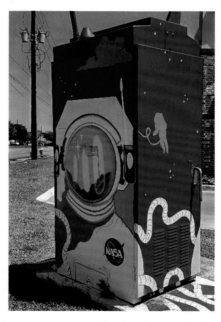

Mini space murals. What do you get when you cross traffic signal control boxes with creative artists and a supportive city arts program? In Houston, you get dozens of "mini murals" celebrating a variety of themes, including space. Launched in 2015, the mini murals can be found on dozens of traffic control boxes around the city.

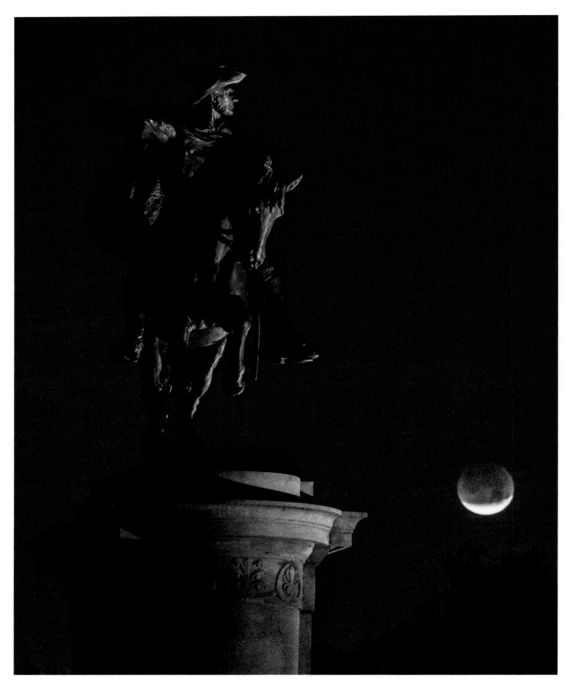

Trifecta lunar event. The lunar eclipse in Houston on January 31, 2018, was a bit of a rarity since it was also the second full moon of the month, known as a blue moon, and it occurred during the moon's closest approach to the earth, known as a supermoon.

Eating the moon. Through the ages, solar eclipses were attributed to supernatural causes or regarded as bad omens. According to Tibetan myths, for example, Yama, the lord of death, lives in the moon. When there is a solar eclipse, the Tibetan people say "Yama is eating the moon!" Today, even partial solar eclipses—like the one observed in Houston in August 2017—can create widespread excitement and draw people outside to witness the heavenly event.

Red rover, red rover. To test prototype vehicles like the small pressurized rover, NASA created the "Mars yard" at Johnson Space Center, complete with rocks, gravel, and hills similar to what might be experienced on the moon or Mars. The rover is a mobile habitat module that would allow crews of four astronauts to explore away from their primary base for up to three days. With a wide field of view, astronauts could work inside the rover without wearing spacesuits and then don them to explore or conduct research on the surface.

Houston, the Future Is Coming

Playing a Major Role in Human Space Research and Exploration

In my own view, the important achievement of Apollo was a demonstration that humanity is not forever chained to this planet, and our visions go rather further than that, and our opportunities are unlimited.

—Neil A. Armstrong, commander of Apollo 11

Few of those who watched Apollo 11 land on the moon and Neil Armstrong take "a giant leap for mankind" in July 1969 would have been able to successfully predict what the US space program would look like over the following ten years, much less the next fifty. Within five years of the moon landing, the bulk of the Apollo program was completed. By 1979, Skylab was shut down and allowed to burn up upon reentry.

The Space Shuttle program, initially envisioned in the 1960s, began with its first launch in 1981. Thirty years and 135 launches later, the shuttle program flew its last mission, and the remaining orbiters were disbursed in 2012 to museums around the country. Houston landed the *Independence*, a high-definition version of a shuttle, and the shuttle transport carrier.

While the concept of a space station had been discussed within the NASA organization as early as 1957, the full-fledged concept did not start to materialize until the first component of the International Space Station was launched in 1998. Permanent occupancy on the $100 billion facility began in 2000, and thousands of experiments have since been performed aboard the orbiting laboratory, which is currently scheduled to remain operational through 2024. While many caveats are warranted, "what's past is prologue" seems appropriate when considering the future role for Houston and the Johnson Space Center in space during the next fifty years.

Preparing humans for long-duration spaceflight

While specific programs remain somewhat fluid, Houston has two key advantages in the next phase of space exploration. First, if the US continues to send humans into space, then the Johnson Space Center is likely to continue its historic role as the lead NASA center for human spaceflight. Regardless of the destination—the International Space Station, the moon, asteroids, or Mars—any crewed mission is likely to involve long-duration flights. This will require more research to ensure the health of the astronauts, which leads to Houston's second distinct advantage: the world-class institutions of the Texas Medical Center.

Several area universities are already working with NASA researchers to address the challenges of long-duration space flight. Baylor College of Medicine, for example, is ranked as the top NASA-funded life science research and development program in the country. The college also established the Center for Space Medicine, the first department or academic center in space medicine ever established in a university or medical school. In addition, Baylor is the

lead institution managing research for the NASA-supported Translational Research Institute's work on finding new concepts and health treatments for long-duration spaceflight missions. The NASA award could be extended to 2028, covering the potential operational life of the International Space Station.

Separately, the University of Houston is engaged in research on improving radiation detection on the International Space Station and future long-duration space flights where astronauts are likely to be subjected to increased exposure to radiation in space. In a relatively new area of space medicine, the University of Texas Medical Branch is working with the Federal Aviation Administration's commercial space transportation center to study how future commercial space flight passengers might respond psychologically to the forces of acceleration that are experienced during a typical commercial spaceflight.

Leveraging Johnson Space Center experience

JSC engineers and scientists have helped develop and operate a variety of space vehicles, and that collective experience will be a valuable asset for the Houston area as future space vehicles and systems are developed. NASA's Commercial Crew Program is working with Boeing on its CST-100 Starliner and with SpaceX and its Dragon crew capsule to fly astronauts to and from the International Space Station. NASA has also used Orbital ATK's Cygnus supply system to support the space station while Sierra Nevada Corp. is developing a robotic Dream Chaser space plane to deliver NASA cargo.

Capitalizing on the country's national research laboratory in space

Houston also potentially could play an important role in dozens of research programs on the International Space Station. The Houston Methodist Research Institute's Center of Space Nanomedicine, for example, has plans to send eight nanoscale experiments to the International Space Station by 2021.

The future of space research in Houston also includes applying NASA knowledge, experience, and technology to address Earth-bound challenges. At the University of Houston, the Sasakawa International Center for Space Architecture's expertise in space architecture and engineering could also be applied to working and living in other extreme environments, including subsea, the Arctic, and the desert, or even in disaster recovery zones.

Balancing government and private sector roles in space

NASA already has begun changing the way it does business through its commercial partnerships efforts to seed commercial innovation to advance humanity's future in space, and NASA will continue to play a dominant role in human space exploration—especially for destinations like Mars that require long-term commitments and heavy-lift rockets. But, the private sector is quickly carving out a significant role in low Earth orbit missions, especially those with focused

research components. Meanwhile, homegrown companies like Ad Astra Plasma Rocket Co. and NanoRacks are developing new technologies and operations that have growth potential in coming years.

Creating a commercial spaceport for the future

Hoping to continue its leading role in space, Houston has a bold vision: a vibrant commercial spaceport on the city-owned land at Ellington Airport near the Johnson Space Center. In 2015, the Houston Airport System won a Federal Aviation Administration license making Ellington Airport the tenth commercial spaceport in the United States and the only one located near a major metropolitan area. This FAA license makes the Ellington Spaceport a potential landing site for suborbital, reusable launch vehicles and supersonic commercial air travel. Working with NASA, Houston area business leaders, educational institutions, and private sector companies, the Houston Airport System aims to create a comprehensive facility that would serve as a support base for future commercial space projects.

The City of Houston also has worked with Sierra Nevada Corp.'s Space Systems to establish future landing operations at the Ellington Spaceport as part of that company's multi-year NASA contract for its Dream Chaser Cargo System delivery service to and from the International Space Station.

Farther, faster. When the US decides to take a giant leap into deep space, it will likely be on the Orion spacecraft. While the final destination is still undetermined, Orion is being designed to take humans farther than they've ever gone before. Orion will launch on NASA's new heavy-lift rocket, the Space Launch System.

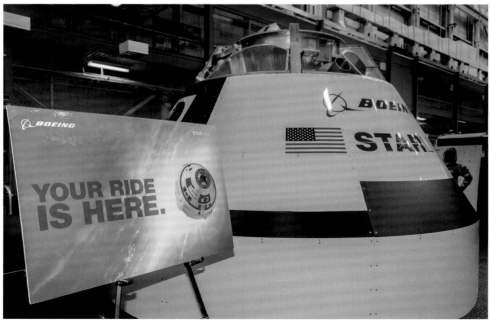

A twenty-first century space capsule. Boeing is working with NASA's Commercial Crew Program to develop its CST-100 Starliner. The new capsule is designed to be able to remain on-orbit for up to seven months and to be reusable for up to ten missions. When launched on existing NASA rockets, it would again enable the United States to send astronauts to the International Space Station instead of relying on Russia for human access to space.

The right stuff. More than 18,000 men and women from all fifty states applied to become astronauts in 2016. A year later, US Vice President Mike Pence joined NASA in naming twelve individuals as astronaut candidates during a press conference at Johnson Space Center. As part of the astronaut class of 2017, Loral O'Hara could become only the second Houston area native selected to fly in space.

A helping hand. Robotics, including devices like the highly dexterous humanoid robot Robonaut 2 (R2) developed by engineers at Johnson Space Center, will play an important role in future long-term space missions.

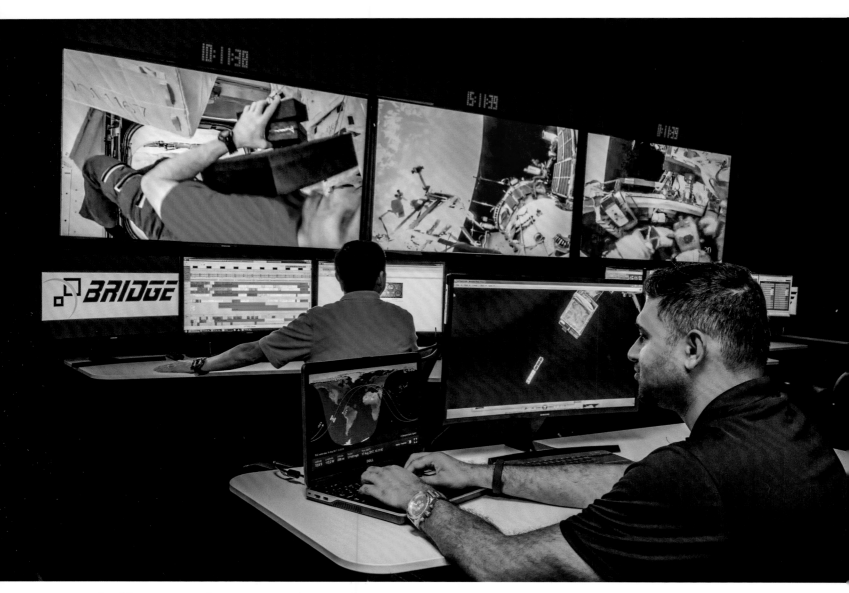

Tracking space packages. NanoRacks created a mini mission control center at its offices in Webster to monitor and track its scientific payloads deployed from the International Space Station.

Houston, we have a spaceport. The Houston Airport System holds a license from the Federal Aviation Administration designating Ellington Airport as the tenth commercial spaceport in the United States. The FAA license makes Ellington Airport a potential launch and landing site for suborbital, reusable launch vehicles. Photo courtesy of the City of Houston Aviation Department

A new day dawning. A new air traffic control tower at Ellington Airport also features dedicated mission control facilities to support commercial spaceflight operators as part of the efforts to create a spaceport for the site near Johnson Space Center.

A century of progress. At the time that the Wright brothers were embarking on the first powered flight in 1903, E. H. Marks was working as a cowboy in far west Houston. More than a century later, the International Space Station regularly passes over a windmill on the site of his former LH7 ranch near Barker, Texas.

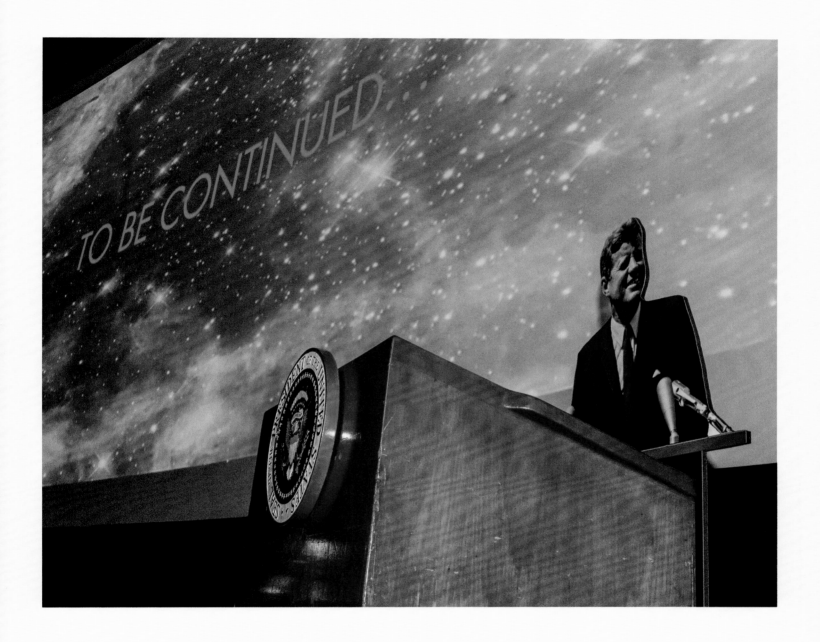

The exploration of space will go ahead, whether we join in it or not, and it is one of the great adventures of all time, and no nation which expects to be the leader of other nations can expect to stay behind in the race for space.

—President John F. Kennedy, Rice University, September 12, 1962

Honoring fallen heroes. When it came time to name its newest football stadium in 2016, the Clear Creek Independent School District chose to honor the space shuttle crews of Challenger (1986) and Columbia (2003). The stadium's field was named Apollo Field in 2017 to commemorate the fiftieth anniversary of the Apollo 1 tragedy, which claimed the lives of astronauts Virgil "Gus" Grissom, Edward White, and Roger Chafee.

Honoring and Remembering

Oh! I have slipped the surly bonds of Earth and . . . put out my hand, and touched the face of God.

—John Gillespie Magee Jr.
"High Flight"

No accounting of America's space program can ignore the human cost of our success. Honor is certainly due to those who gave their lives in our reach toward what the poet John Gillespie Magee Jr. called "the high untrespassed sanctity of space."

Apollo 1	*Challenger*	*Columbia*
Roger Chafee	Gregory Jarvis	Michael P. Anderson
Virgil "Gus" Grissom	Christa McAuliffe	David M. Brown
Edward White	Ronald McNair	Kalpana Chawla
	Ellison Onizuka	Laurel B. Clark
	Judith Resnik	Rick Husband
	Dick Scobee	Willie McCool
	Michael A. Smith	Ilan Ramon

"High Flight"

Oh! I have slipped the surly bonds of Earth
And danced the skies on laughter-silvered wings;
Sunward I've climbed, and joined the tumbling mirth
of sun-split clouds,—and done a hundred things
You have not dreamed of—wheeled and soared and swung
High in the sunlit silence. Hov'ring there,
I've chased the shouting wind along, and flung
My eager craft through footless halls of air. . . .
Up, up the long, delirious, burning blue
I've topped the wind-swept heights with easy grace.
Where never lark, or even eagle flew—
And, while with silent, lifting mind I've trod
The high untrespassed sanctity of space,

 —Put out my hand, and touched the face of God.

President Ronald Reagan used part of "High Flight" in a speech honoring the *Challenger* astronauts.

"Flying for Me"

Singer and songwriter John Denver was an avid space enthusiast and worked to try to convince NASA to create a civilian in space program. Following the *Challenger* accident on January 28, 1986, he wrote "Flying for me" in honor of the lives of the six astronauts and civilian teacher Christa McAuliff who were aboard. Denver performed the song publicly for the first time during a benefit concert on March 27, 1986, at Jones Hall in Houston, organized in part by former JSC director Gerry Griffin. Also performing were the Houston Symphony Orchestra, Houston Grand Opera, Houston Ballet, and children from the Theatre Under the Stars' Humphrey's School of Musical Theatre.

Houston pays tribute to Challenger, Columbia crews. Houston honored the astronauts who died in the Challenger and Columbia accidents with memorials located next to Tranquillity Park in downtown Houston.

Lasting legacies, living memories. Johnson Space Center created the Astronaut Memorial Grove of live oak and other trees to honor astronauts in 1996. The grove includes dedicated areas for the astronauts from Apollo 1, Challenger, and Columbia. A year after his death in 2012, Apollo 11 astronaut Neil Armstrong was honored with a tree, a special plaque, and a concrete replica of a boot print like the one he left on the moon.

Space trophy. The Space Center Rotary Club of Houston holds a gala in Houston each year to award the National Space Trophy to an individual in recognition of their outstanding achievements in space. The seven-foot, 500-pound, conical column was designed by Steuben Glass to rise like a rocket above a base that is reminiscent of exhaust clouds or the frozen moons of some distant world. Past recipients have included astronauts Neil Armstrong, Gene Cernan, Eileen Collins, Richard Truly, and John Young; former NASA directors; former JSC directors George Abbey, Aaron Cohen, and Christopher Kraft; President George H. W. Bush; and Senator Kay Bailey Hutchison.

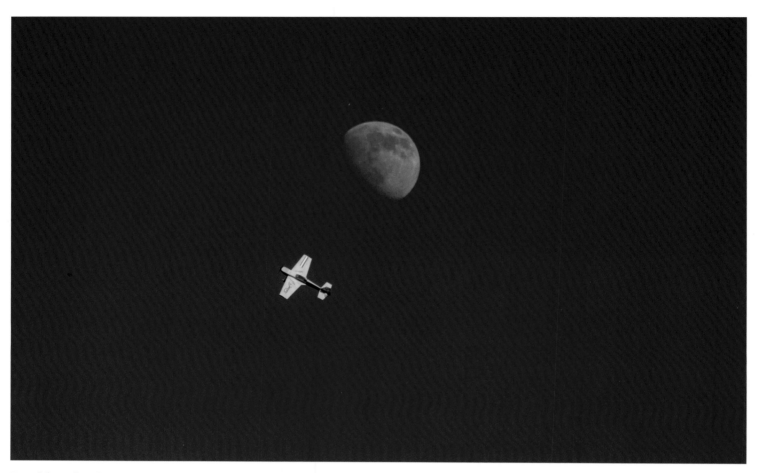

Touching the sky. One of the area's largest model airplane parks is named in honor of Challenger astronaut Dick Scobee. The Dick Scobee Memorial Airfield in west Houston is the home to the Bayou City Flyers, chartered by the Academy of Model Aeronautics. The fields include a 630-foot × 80-foot paved runway for fixed wing powered radio control model aircraft and an adjacent area within the fly zone for RC helicopters and multirotor (drone) model aircraft.

Apollo 11 moon. The moon was in the waxing crescent moon phase when Apollo 11 landed on the Sea of Tranquility on July 20, 1969.

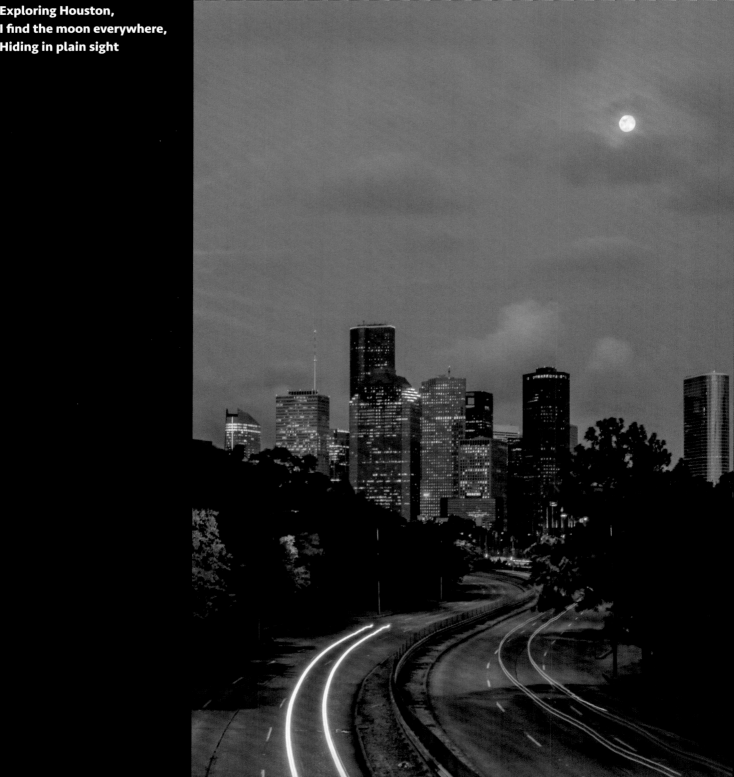

Exploring Houston,
I find the moon everywhere,
Hiding in plain sight

References

Allton, Judith Haley, Patricia M. Brackett, and Dana Ray. *The Little White Church on NASA Road 1, From Rice Farmers to Astronauts*. Webster, TX: Webster Presbyterian Church, 1993.

Bruns, Laura, and Mike Litchfield, eds. *Johnson Space Center: The First 50 Years, Images of America*. Charleston, SC: Arcadia Publishing, 2013.

Burke, Ruth, and Rebecca Collins. *Around Clear Lake, Images of America*. Charleston, SC: Arcadia Publishing, 2013.

Dethloff, Henry C. *Suddenly Tomorrow Came: The NASA History of the Johnson Space Center*. Mineola, NY: Dover Publications Inc., 2012.

Dick, Steven. *America in Space: NASA's First 50 Years*. New York: Harry N. Abrams Publishing, 2007.

Kennedy, John F. Excerpt from the "Special Message to the Congress on Urgent National Needs," May 25, 1961.

Kennedy, John F. Text of President John F. Kennedy's Rice Stadium Moon Speech, September 12, 1962.

Kranz, Gene. *Failure Is Not An Option*. New York: Simon & Schuster Paperbacks, 2000.

Mailer, Norman. *MoonFire: The Epic Journey of Apollo 11*. Cologne, Germany: Taschen GmbH, 2009.

Pratt, Joseph A., and Cristopher J. Castaneda. *Builders: Herman and George R. Brown*. College Station, TX: Texas A&M University Press, 1999.

Sagan, Carl. *Pale Blue Dot: A Vision of the Human Future in Space*. New York: Ballantine Books, 1994.

Sparrow, Giles. *Space Flight: The Complete Story from Sputnik to Shuttle—and Beyond*. New York: DK Publishing, 2007.

Moon in blue. The phrase "blue moon" is now commonly understood to mean the second full moon within a single calendar month. The phrase "once in a blue moon" reportedly has been around for more than four hundred years. It originally suggested "never" but is now commonly understood to mean "rarely."

Index